Drawing Nature for the Absolute Beginner

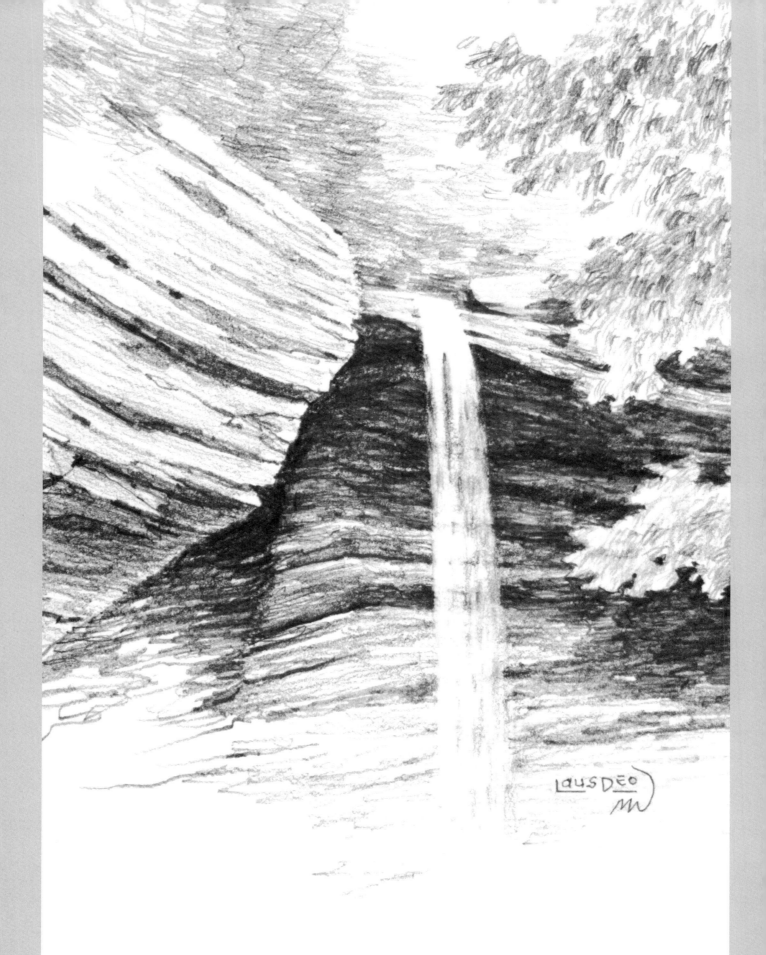

drawing nature _{for} _{the}
absolute beginner

Mark and Mary
Willenbrink

NORTH LIGHT BOOKS
CINCINNATI, OHIO
www.artistsnetwork.com

Contents

Chapter 1
Drawing Techniques • 12

Methods of sketching and drawing, and how to apply them.

Chapter 2
Art Principles • 22

Visual concepts such as composition, perspective, values and light and shadow help create compelling works of art.

Chapter 3
Natural Subjects • 36

Subjects found in nature can include animals such as birds, deer and insects, and inanimate objects like trees, flowers and water.

Chapter 4
Let's Draw! • 66

Apply what you've learned with these demonstrations.

On page 2:

Ash Cave Waterfall
Graphite pencil on drawing paper
8½" × 5" (22cm × 13cm)

Introduction

Have you ever experienced the peace of walking through the woods or the excitement of a storm gathering on a beach? Artwork provides the ability for us to capture those moments and share them with others.

Combining your love of nature with your interest in art, this book will help you develop the skills necessary for drawing. You will learn the proper tools to use, how to apply techniques to your drawings and make use of some of the tricks professionals use every day. You will also learn basic art principles and develop your observational skills.

Drawing is a skill that improves with practice. Be an active participant while going through this book by taking a sketch pad and pencil with you when you go out to enjoy nature, and consider using a digital camera to collect your own reference photos.

Everyone is an artist, including you, so get ready to have fun!

Materials

Pencils
2B, 4B, 6B and 8B graphite pencils

Paper
9" × 12" (23cm × 30cm) medium-texture drawing paper
9" × 12" (23cm × 30cm) medium-texture sketch paper
9" × 12" (23cm × 30cm) rough-texture drawing paper

Other Supplies
angle ruler

blending stump

dividers or sewing gauge

drawing board

eraser shield

folding stool

kneaded and plastic erasers

lightbox

masking tape

pencil extender

pencil sharpener

spray fixative

tote box

tracing paper

transfer paper

value scale

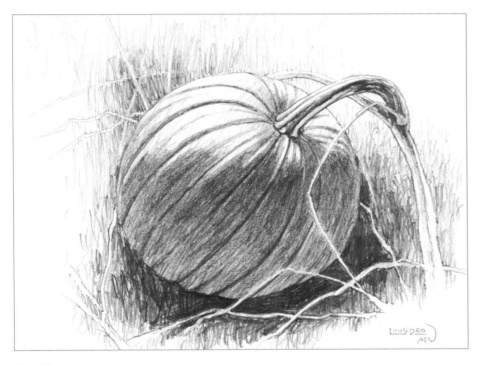

Pumpkin
Graphite pencil on drawing paper
8½" × 11" (22cm × 28cm)

The materials used for drawing nature can be as simple as a pencil and paper, or you may choose a more elaborate outfit. However you choose to equip yourself, it is always good to understand the materials you are using.

Pencils

The different types of pencils offer different results. Pencils vary with their core and their casing. Though pencils do not contain lead, the core is often referred to as lead.

2B or Not 2B

Those numbers and letters stamped onto pencils refer to the hardness/softness of the lead of the pencil. Pencils are labeled with letters referring to their degree of hardness or softness. H is for hard lead, B is for soft lead, and F and HB pencils are in between the hard and soft categories. The numbers refer to how hard or soft the lead is within that letter range; the higher the number, the more noticeable the characteristic. This means that a 4H pencil has a harder lead than a 2H pencil, whereas a 4B pencil has a softer lead than a 2B pencil.

Hard lead pencils keep their point longer, but can't make rich darks compared to soft lead pencils.

When choosing what pencils to use for a drawing, keep in mind that you may only need two or three pencils to achieve a range of light and dark linework.

Graphite, Carbon and Charcoal
Graphite is commonly used as a core, as are carbon and charcoal. Graphite offers controlled results if you want to achieve extreme darks. Carbon or charcoal can be used, though these two types are easier to smear.

Hard or Soft
Hard lead pencils may stay sharp longer, but can't make rich darks like the soft lead pencils.

Woodless Pencils
These types of pencils have no outer casing, just an outer layer of lacquer that covers the graphite core. Because the core is so broad, wide line strokes are possible. Since there is no outer casing, woodless pencils are prone to breaking.

Colored and Pastel Pencils
Colored pencils offer a broad range of colors, including grays, white and black, but can be waxy and difficult to erase. Pastel chalk pencils are softer and easier to erase than standard colored pencils while still providing the many color options.

Mechanical Pencils and Lead Holders
Mechanical pencils are convenient to use but will only produce narrow line strokes because the graphite lead is so thin. Lead holders can hold a thicker piece of lead than other mechanical pencils, so they are able to produce wider strokes. Though lead holders are similar in appearance to traditional wood pencils, their lead is more apt to break if too much pressure is applied during use.

Weight, content, surface texture, size and format are all considerations when choosing sketching and drawing paper. Gray and colored papers are also options and can work as the middle value of a drawing. In that case, add the lighter and darker values with charcoal, pastel or colored pencils.

Weight

Differences of paper weight are noticeable in the thickness of the paper. The heavier the weight, the thicker the paper. Sketch paper is typically thinner than drawing paper with a weight of around 50 to 70 lbs. (105gsm to 150gsm). Drawing paper usually weighs 90 lbs. (190gsm) or more for the purpose of withstanding erasing and heavy pencil pressure.

Content

Paper is made from wood pulp (cellulose) or cotton or both. Paper made with wood pulp has acid, which causes yellowing with age. Cotton is acid free, which means the higher the cotton content of the paper, the less prone it will be to yellow over time.

Surface Texture

Also referred to as tooth, the surface texture of paper may be smooth or rough, or somewhere in between. Smooth paper works well for a detailed graphite drawing whereas rough paper is good to use when drawing with soft pencils such as charcoal and pastel.

Size and Format

Whether big or small, in pads or individual sheets; these are all considerations when purchasing paper. A small pad is convenient for travel, a big pad is useful for big, loose sketching. The more expensive paper, which is purchased as individual sheets, may be used for finished drawings when a quality paper is needed.

Drawing Boards

The smooth, hard surface of a drawing board allows for better control when applying pressure to the pencil than working on a pad of paper or cardboard. Some drawing boards have clips to hold the paper and a cut-out handle to make carrying easier.

In addition to the basic supplies, there are other tools that will make your drawing experience go smoothly.

Pencil Sharpeners

Sharpening a pencil can be done using a pencil sharpener or by trimming your pencil by hand with a craft knife and sandpaper pad.

Erasers

Sometimes it may be necessary to erase pencil lines when drawing. Of the different types of erasers, the two most common types are kneaded and plastic.

Avoid using the eraser at the end of a pencil. It won't give you the same results.

Hand-Held Pencil Sharpeners
Small, hand-held pencil sharpeners may look different but perform the same task—trimming the pencil to a point.

Trim With a Craft Knife
Trimming by hand may be the only way to sharpen pastel and charcoal pencils.

To trim a pencil by hand, hold the pencil firmly with one hand and hold the craft knife in the other, with the blade away from your thumb and against the tip of the pencil. Create leverage by pushing the thumb holding the pencil against the thumb holding the knife. Trim a section of wood around the lead. Position the pencil for another cut and continue the process until the wood is trimmed completely around the lead.

Sharpen the Lead of Lead Holders
With a section of the lead exposed from the holder, sharpen it using a rotary sharpener. Slip the lead holder down into the sharpener and spin the top around to form the lead to a point.

Sharpen With a Sandpaper Pad
To sharpen the lead, drag the lead up and down over the surface of the sandpaper pad to form a point.

Kneaded Erasers

Kneaded erasers are soft and have a consistency like putty. They are less abrasive than other erasers and are less likely to roughen up the surface of the paper. Some erasing can be done by pressing the kneaded eraser to the paper surface and lifting.

Plastic Erasers

Plastic erasers may be white or black and characteristically leave behind strings rather than crumbs of the spent eraser.

Eraser Shield

This thin piece of metal or plastic is used to isolate an area of the paper for controlled erasing.

Proportioning Devices

Dividers are a compass-like device used for proportioning and comparing sizes for drawing. Use when working from photographs. A sewing gauge is a measuring device that can be used for proportioning photos or real life subject matter.

Angle Ruler

This clear plastic ruler can pivot in the middle allowing it to fold at various angles. Use it like a standard ruler, to measure and proportion, but it can also be used to transpose angles.

Blending Stump

Made of rolled paper, use a blending stump to smooth the linework of a drawing by gently rubbing the end of it across the surface of the paper.

Lightbox

A lightbox is used to trace a previously drawn structural sketch onto drawing paper, thus avoiding unwanted pencil lines and excessive erasing on the drawing paper. To do this, tape a sheet of drawing paper over the structural sketch, then place it on the lighted lightbox and trace the image onto the drawing paper.

Transfer Paper

Another method for transferring an image onto drawing paper is to use transfer paper, also called graphite paper.

The process involves taping the initial sketch to the surface of drawing paper graphite-side down, placing a sheet of transfer paper between the sketch and drawing paper, then redrawing the image with a hard lead pencil. This presses the graphite from the transfer paper onto the drawing paper, transferring the sketch onto the drawing paper.

Transfer paper can be purchased ready for use, or can be made by covering one side of a sheet of tracing paper with soft graphite, then wiping across the surface with a cotton ball slightly dampened with rubbing alcohol to bind the graphite to the tracing paper.

Spray Fixative

Fixative is used to bond the linework to the paper surface and can prevent the smearing of soft lead pencils such as charcoal or pastel. Fixative should only be sprayed onto artwork in an area that is well ventilated.

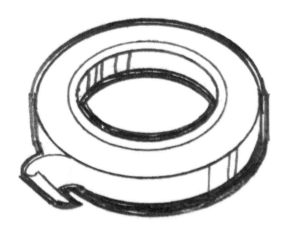

Masking Tape

Masking tape is used to adhere one piece of paper to another. We use name brand masking tape because it grips firmly yet releases with minimal concern for tearing the paper.

Drawing Indoors and Outdoors

When we draw indoors, it's usually accomplished by looking at photographs, whereas the act of drawing outdoors involves observing the actual "live" subject. Both settings have advantages and drawbacks. Combine the two processes by making observational sketches and photographs of the subject outdoors, then completing the drawing inside using your previous sketches and photographs for reference.

Drawing Indoors

Drawing indoors offers a comfortable work environment with all tools ready at hand. The subject matter is provided through reference photos and preliminary sketches.

Drawing Outdoors

Drawing outdoors allows for first-hand observation of the subject however the lighting and form of the subject may constantly be changing.

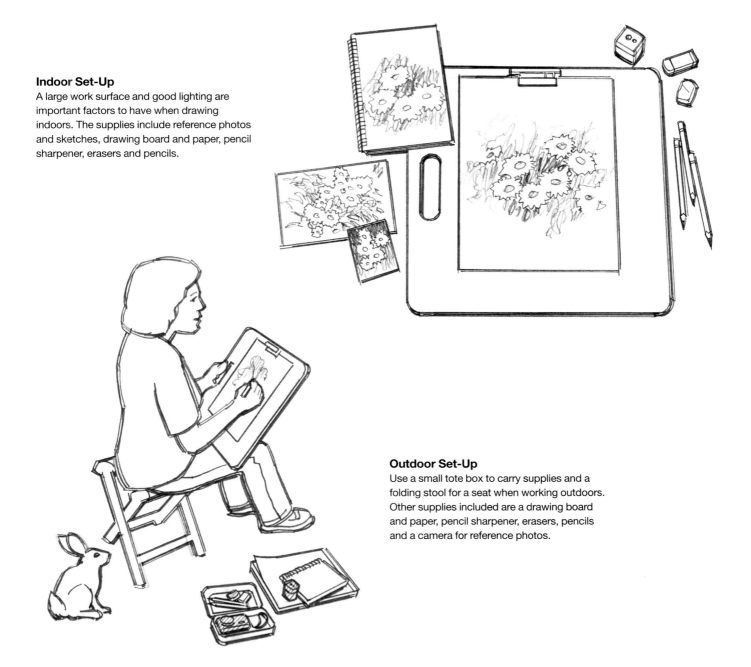

Indoor Set-Up
A large work surface and good lighting are important factors to have when drawing indoors. The supplies include reference photos and sketches, drawing board and paper, pencil sharpener, erasers and pencils.

Outdoor Set-Up
Use a small tote box to carry supplies and a folding stool for a seat when working outdoors. Other supplies included are a drawing board and paper, pencil sharpener, erasers, pencils and a camera for reference photos.

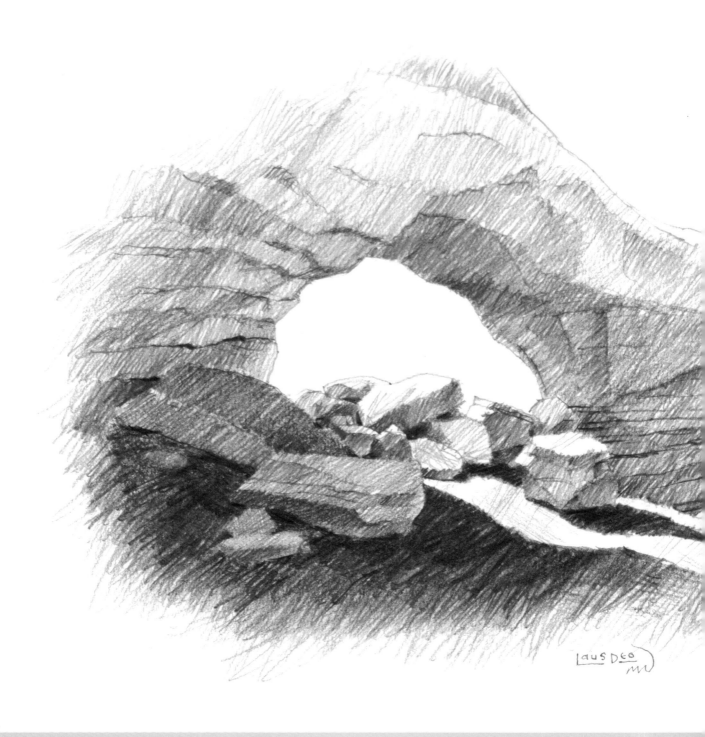

Natural Bridge
Graphite on drawing paper
11" × 14" (28cm × 36cm)

1

Drawing
Techniques

Techniques are the methods used in drawing,
such as pencil grips and strokes, blocking-in and
proportioning. Applying these techniques will make the
drawing process more successful.

Sketches may be quick and loose when observing and understanding the subject or planning the composition for a drawing. A drawing is a finished work of art, and may be the culmination of previous sketches.

When choosing between sketching and drawing, consider the amount of time that you have available and whether you want to take it to finished art.

Pencil Grips, Strokes and Lines

Line quality is affected by the type of pencil, the paper and the grip you use to apply the lines. Your grip will affect the angle of the pencil and influence the line width. Wider lines can be made when the pencil is almost horizontal to the paper surface, allowing most of the lead to be in contact with the paper. You can make narrow lines when the pencil is perpendicular to the paper surface, causing only the point to be in contact with the paper.

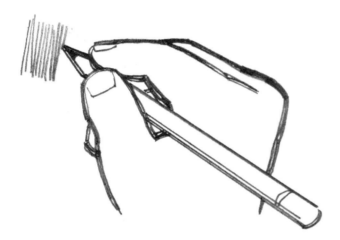

Handwriting Grip
Narrow, controlled lines can be made by holding the pencil close to the point with this handwriting grip. Longer lines can be made by holding the pencil farther from the point; however, the linework will be less controlled.

Point Pressure Grip
This grip holds the pencil flat against the paper with the index finger close to the point. Pressure is easily applied to the point to make loose pencil lines that can be wide and dark. The linework made with this grip will feel less controlled than with the handwriting grip.

Loose Grip
This grip holds the pencil almost flat against the paper like the point pressure grip, but the index finger is moved away from the point and the pencil end is placed in the palm. The pencil lines created can be long, loose and wide for free flowing sketching.

Arc Grip
Long, arcing lines can be made by holding the pencil away from the tip with the hand resting on the paper. The pencil point may be extended so that the end is seated in the palm of the hand.

Shading and Texture

The lead, the grip of the pencil and the paper surface can all influence the shading and texture of a drawing.

Shading

Shading displays the values (lights and darks) of the subject and is done through pencil strokes that can add patterns and direction to the artwork. There are many different ways to create shading. Some types of shading will feel more natural to you than others. Try experimenting with these techniques or make up some of your own to best express the subject you are drawing.

Parallel Lines
This type of shading places parallel lines next to each other as a pattern.

Crosshatching
Overlapping parallel lines create a crosshatching effect.

Graduating Lines
Graduating lines can be made by going heavy to light with every stroke or by changing the amount of pressure gradually with a group of back and forth strokes.

Scribbling
Sharp and pointed or round linework are just two examples of scribbling that can be used to imply texture.

Implying Texture

The texture of a subject can be implied through the application of the pencil interacting with the surface of the paper.

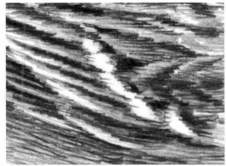

Feather Texture
A bird's feathers can be drawn using soft and hard lead pencils applied to smooth paper for contrasting values.

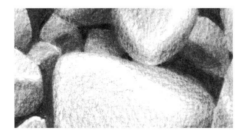

Rock Texture
Soft lead graphite applied to the coarse surface of medium-texture paper implies the rock's bumpy appearance.

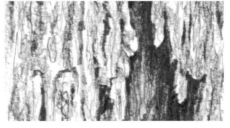

Tree Bark Texture
Tree bark can be drawn using soft and hard lead pencils applied to medium-texture paper, making wide and narrow lines with lots of contrast.

Fur Texture
Short, narrow pencil lines placed on smooth paper create the feel of a squirrel's fur.

Different Approaches

There are many different approaches to sketching and drawing. Two approaches are structural sketches and value sketches, which will be used throughout this book. The structural sketch interprets form through basic line and shape. Values are the lights and darks of an image.

Combine a Structural Sketch With Values

The two approaches, structural sketch and values, can be combined as a process to create finished drawings.

Sketch the Structure
Using simple linework, sketch the structure of the subject with basic shapes that make up the form.

Look for the Values
Look for the lights and darks of the subject.

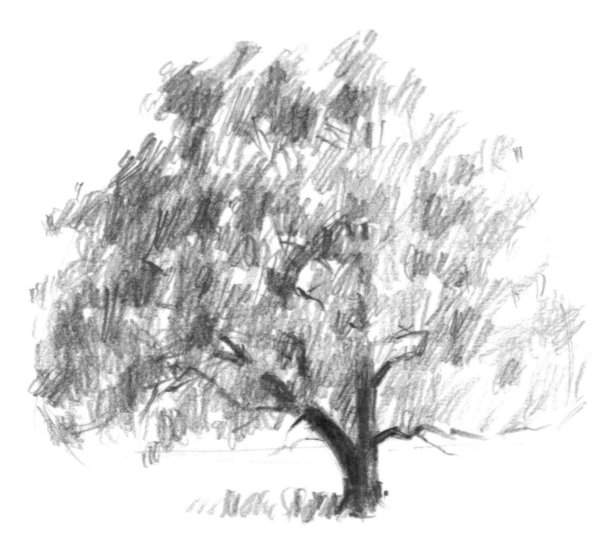

Complete the Drawing
Add the values of the subject, using the structural sketch as a guide for their placement to complete the drawing.

Blocking-In With Basic Shapes

Basic shapes, such as circles, squares and triangles, can be used as forms to create the structural sketch. This process is also referred to as blocking-in.

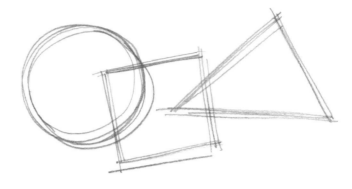

Look for Circles
Circles and elliptical shapes may be used for the drawing of flowers. Start by sketching the perimeter of the petals. A smaller circular shape is sketched for the center. Petal shapes are sketched between the two circle shapes and another, more elliptical shape is sketched at the center.

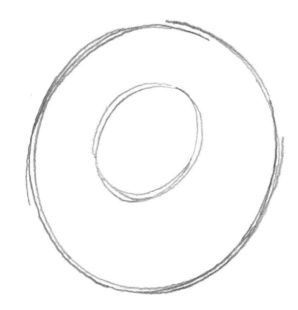

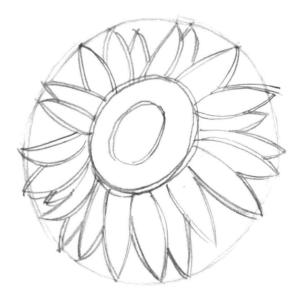

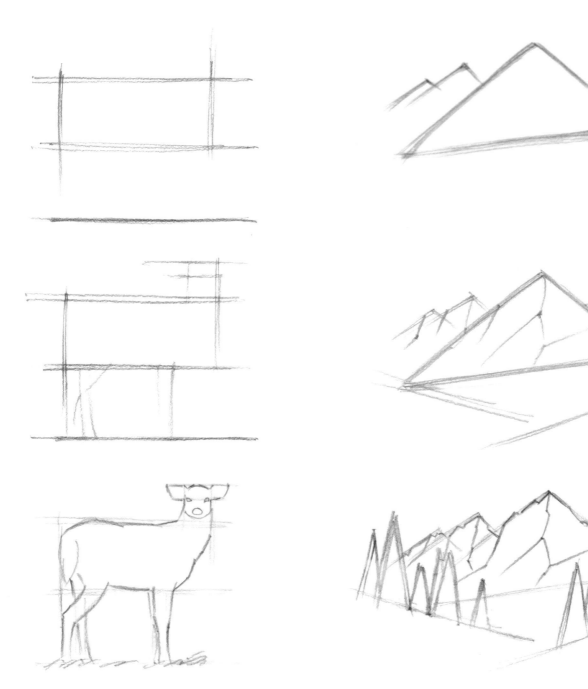

Look for Squares and Rectangles

Squares and rectangles can be used to sketch the basic form of subjects such as animals by first sketching a rectangle for the body along with a baseline where the feet or hooves would rest. More straight lines are added for the head and legs. Next, the lines are contoured and details are added to form the animal.

Look for Triangles

The overall shape of mountains may be sketched using basic triangles, beginning with the biggest shapes. More lines are added to suggest the forms and shadows. Then add detail to the mountains and trees in the foreground.

Proportioning, Comparing & Transposing

The basic shapes of the structural sketch need to be accurate to be believable. Proportioning, comparing and the transposing of lines are practices that need to be developed to make a sketch accurate.

Proportioning

Proportioning involves the comparing of elements such as comparing the height of an object to its width. This information is then applied to the sketch. Different tools can be used for proportioning, including a divider, sewing gauge or a pencil.

Determine a Unit of Measurement
For this subject, the distance of the height of the cactus is used as a unit of measurement.

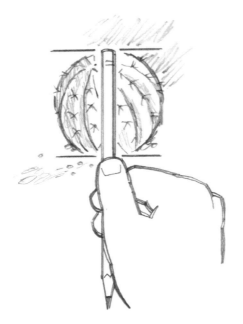

Compare the Size
The distance of the height when compared to the width is the same.

Proportioning a Distant Subject

With this technique of proportioning, a pencil is held in the hand, straight up and down at arm's length. The distance between the top of the pencil and the top of the thumb is used as a unit of measurement when viewed against the subject in the distance. The arm must be kept straight for consistency. A sewing gauge can be used instead of a pencil with this technique.

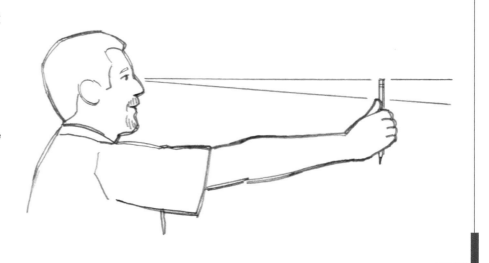

Line Comparisons

A straight tool, such as a pencil, can be used to study the placement of elements by their relationship to one another.

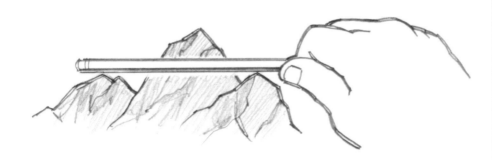

Using a Pencil for Line Comparison
By holding a pencil horizontally, you can see that two of the mountain peaks line up and are the same height as one another.

Transposing Angled Lines

The angled lines of a subject can be transposed to a sketch with a pencil or an angle ruler.

Using a Pencil to Check Angled Lines
Align the pencil so that it is alongside the subject. With the pencil held firmly in your hand, keep the angle as you move your hand over the paper and adjust the line of your sketch.

Using an Angle Ruler to Check Angled Lines
Holding the stem of an angle ruler either horizontally or vertically, align the angle of the ruler to that of the subject. Move the ruler over to the paper. With the stem of the angle ruler parallel to the paper's edge, sketch the angled line.

Keep Those Light, Loose Lines

Begin a structural sketch with light, loose lines that are built upon with darker, more accurate lines. Those initial lines, while they may be inaccurate, should remain on your paper as a form of reference to place your more accurate lines. By sketching this way, erasing may be obsolete and your concentration will not be interrupted with the stop-start process that occurs when erasing.

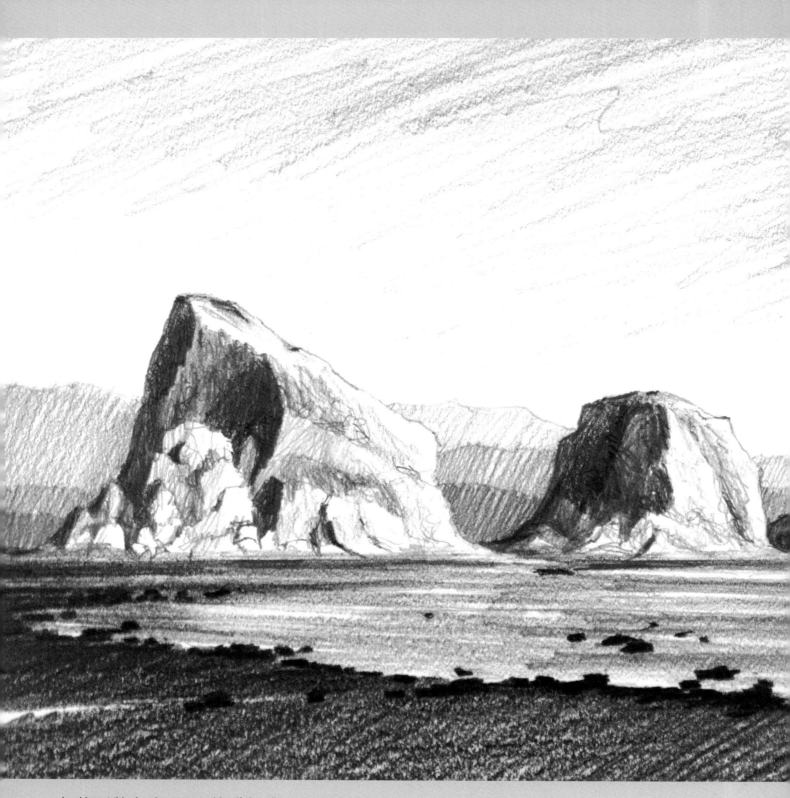

Looking at this drawing, can you identify how linear perspective and atmospheric perspective was used? Read on to gain a better understanding of perspective.

Coastal Cliffs
Graphite pencil on drawing paper
6" x 10" (15cm x 25cm)

2

Art
Principles

Art principles are visual concepts such as perspective, values, light and shadow and composition. Drawing can utilize two types of perspective: linear and atmospheric. Applying these art principles will add a sense of believability to your drawings. They can also be used in other forms of art.

Finding Perspective
Linear perspective is noticeable because the rock formations appear bigger than the distant hills. Atmospheric perspective is noticeable because the closer elements have a wide range of values and more details whereas the distant hills become more neutral and are less detailed.

Linear Perspective

Linear perspective implies depth through the size and placement of the elements. Closer elements appear larger to the viewer. Vanishing points and horizon are features of linear perspective, though they may not be as noticeable in nature as with an environment that includes man-made elements.

Understanding and applying the principles of linear perspective will add depth through the structure of your drawing.

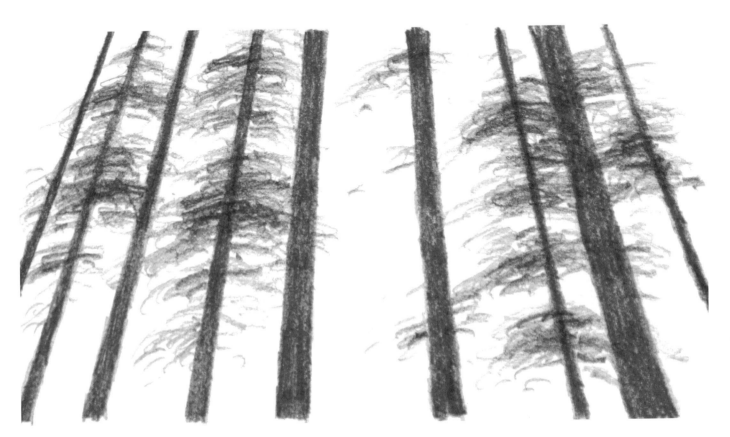

Looking for Linear Perspective in Nature
By looking up at a forest of trees, linear perspective is observable by the direction of the tree trunks. If lines were continued upward, it would show that they meet at a single vanishing point.

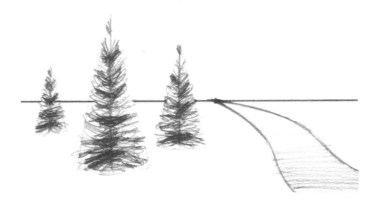

Closer Elements Appear Bigger
Assuming all of the trees are the same size, the trees closer to the viewer will appear bigger.

Parallel Elements Appear to Converge
The parallel sides of the river visually converge in the distance, making or creating a vanishing point. The vanishing point in this scene rests on the horizon.

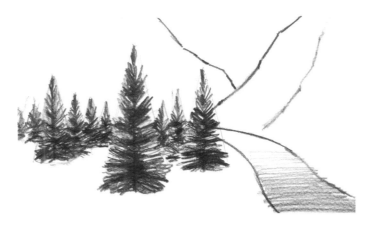

Vanishing Points and Horizon May Be Hidden
Though hidden behind trees and mountains, the vanishing point and horizon still influence the elements in this scene.

Overlapping Elements Express Depth
Another way that depth is expressed is through the overlapping of elements. In this example, the overlapping tree appears closest.

Values

Values are the lights and darks that make up a drawing. Values can communicate depth and form to a subject and can appear to be lighter or darker depending upon the surrounding values.

Contrast

Contrast refers to the difference between values.

Gauging Values

Gauging values involves comparing the lights and darks of the subject matter to that of the drawing. A value scale, which displays a range of grays, black and white, is useful for gauging values.

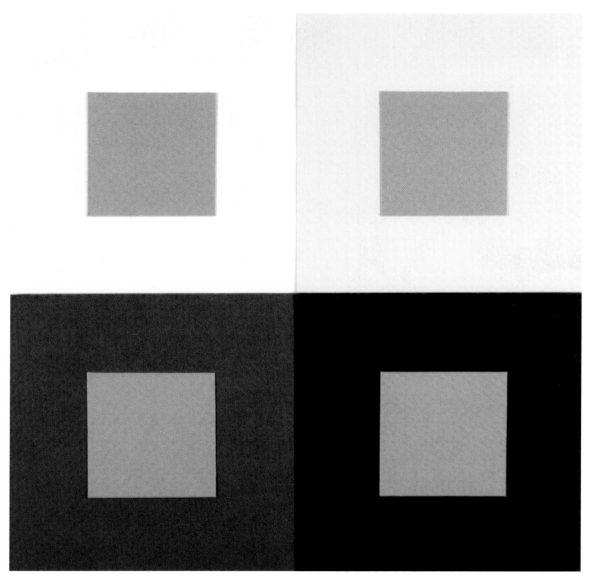

Same Yet Different
Though the four smaller squares are the same value, they appear darker against a light background and lighter against a dark background.

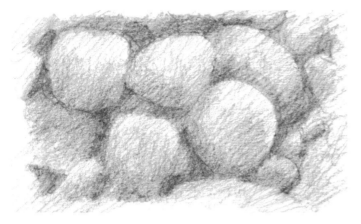

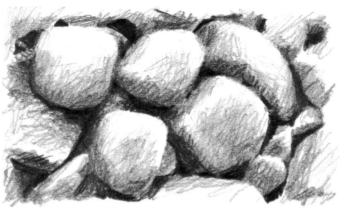

Using Similar Values
A soft, almost flat appearance is made using similar values that are low in contrast.

Using a Broad Range of Values
A realistic dimensional appearance can be achieved when using a broad range of values, including white areas, middle grays and darks.

Using Highly Contrasting Values
A stark, dynamic feel can be made by using values that are highly contrasting, going from white to darks, with very few middle values.

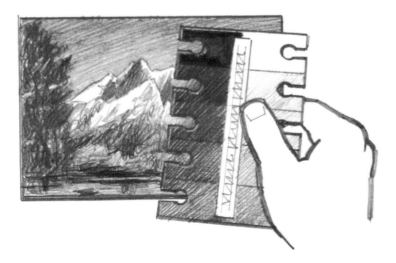

Using a Value Scale
A value scale is also known as a gray scale or value finder. It can be placed over the subject, and then over the drawing, to compare or gauge the values. This method is more accurate than to just guess the values because the values can appear different depending on their surrounding values.

Value scales can be purchased at art stores, or you can make your own by using a strip of drawing paper and graphite pencils.

Light and Shadow

Good drawing involves awareness of the lighting of a subject. The placement and intensity of the light source affects the lights, darks and shadows of the subject. The aspects of lighting include highlights, form and cast shadows, and reflected light.

Light Source

The light source is the origin of light that influences the lights, darks and shadows of a scene. A scene may have more than one light source.

Highlight

A highlight is a bright spot where light reflects off of an object.

Form Shadow

A form shadow appears on an object, displaying the form of the object.

Cast Shadow

Typically darker than form shadows, a cast shadow is caused by an object casting a shadow onto another surface.

Reflected Light

Reflected light is light that is bounced from one surface onto another.

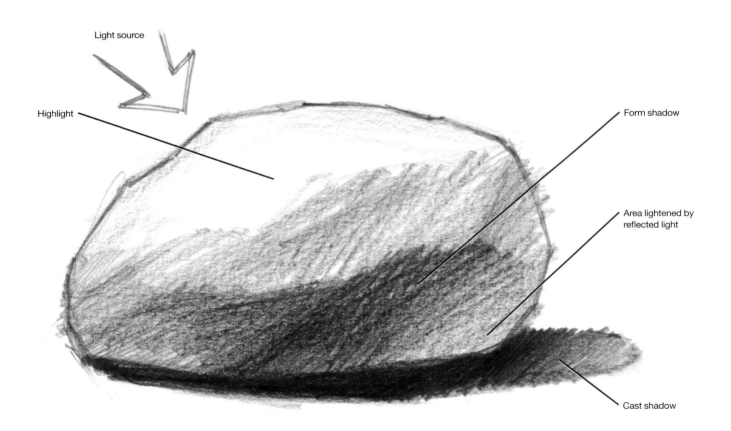

Light source

Highlight

Form shadow

Area lightened by reflected light

Cast shadow

Light and Shadow
The lights, darks and shadows of a scene are influenced by the light source.

Atmospheric Perspective

Also called aerial perspective, atmospheric perspective displays depth through values and definition. The closer elements have contrasting values and well-defined features. As elements become more distant, their values become neutral and may appear hazy. The elements will be less defined.

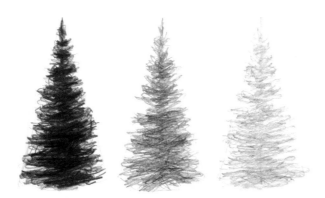

Atmospheric Perspective
Atmospheric perspective expresses depth through values. Elements appear to fade into the distance with atmospheric perspective.

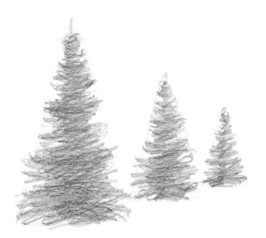

Linear Perspective
Linear perspective expresses depth through size and placement of the elements. The elements appear smaller as they become more distant with linear perspective.

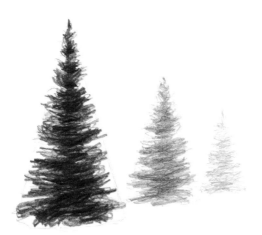

Atmospheric and Linear Perspectives Combined
Depth is expressed through value changes, as well as the size and placement of objects when atmospheric and linear perspectives are used together in a scene.

Composition

Composition is the arrangement of elements in a drawing and is an aspect of all art. Good composition is usually the result of thought and planning by the artist, involving the right balance to feel complete.

Design Elements

Design elements are the pieces that make up a composition. Some of the elements include size, shape, line and values. Color is another element, but this book only pertains to black, white and grays.

Design Principles

Design principles refer to the application of elements. Some of the principles include balance, unity, dominance and rhythm.

Balancing the Elements

Balance in composition can be symmetrical or asymmetrical.

Numbers of Elements

The amount of elements in a composition can affect the feel of a composition. In general, odd amounts of elements are more interesting than even amounts of elements.

Symmetrical Composition

The elements in a symmetrical composition are evenly distributed from side to side, giving a formal appearance.

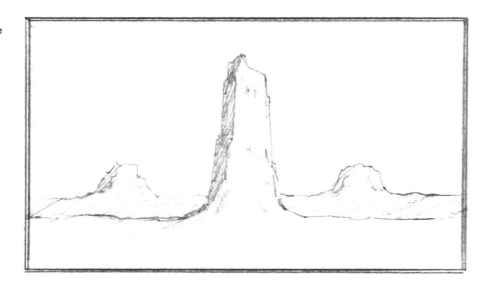

Asymmetrical Composition

The elements in an asymmetrical composition may be placed in an informal manner, but maintain a balanced appearance.

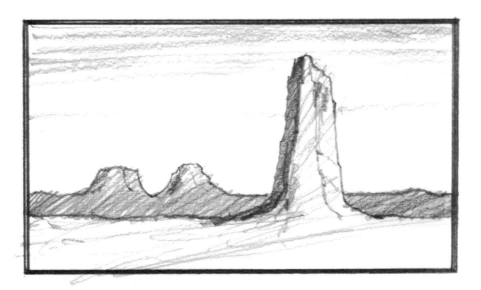

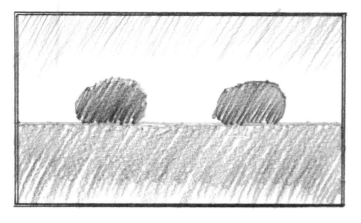

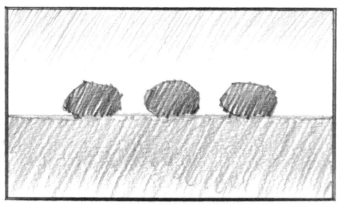

Even Amounts Are Predictable

A composition can seem predictable and lack interest, especially with only two elements to focus on.

Odd Amounts Add Interest

Having three elements can be more interesting than just two, but this symmetrical composition can still be improved upon.

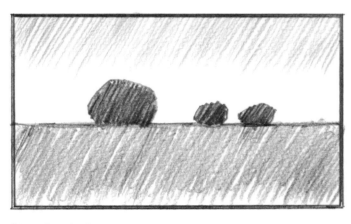

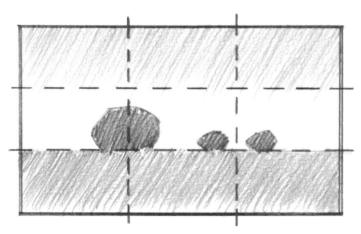

Changing the Balance

By changing the size and spacing of the elements, the composition is now balanced asymmetrically. Though there is unity through the shape of the elements, the larger one is more dominant than the two smaller elements, adding interest to the scene.

Using the Rule of Thirds

One method to make an appealing composition is to use a grid to divide the drawing into thirds, three high by three across, then place the elements in correspondence to the grid lines.

Design by Nature

The "golden ratio" is found throughout nature, whether in DNA or nautilus shells. This ratio is derived by using two successive numbers from the Fibonacci sequence, which goes 0, 1, 1, 2, 3, 5, 8, 13 and so on. Add together the two previous numbers in the sequence to get the next number.

This proportion as a rectangle is used in art and architecture. The spiral, made by progressively building on itself, can be used as a template for visual compositions.

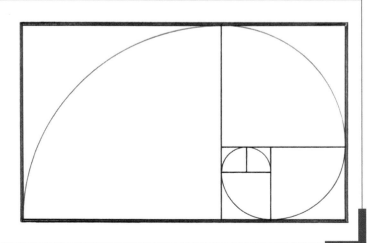

Planning a Composition

Leading the Eye

Elements can be placed in a composition to lead the eye of the viewer and create a sense of motion. Using motion while alternating different elements can create a sense of rhythm.

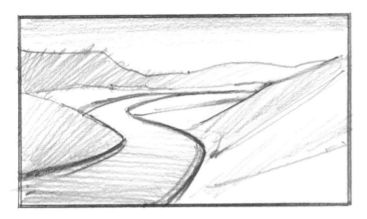

Leading With Line
The eye of the viewer can be led through the composition with the use of line as if to point the way.

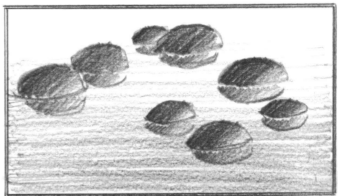

Leading With Shape
Shapes can be used to lead the eye of the viewer through a composition just like stepping stones.

Cropping the Composition

It can be hard to decide how much of a scene should be included in a composition, especially when drawing outdoors. A viewfinder can help to crop an image before starting on a piece

of artwork. Just because you see something doesn't mean that it has to be included in your composition. Let's say there is a telephone pole or wire in a composition that you are working on; you can omit that without losing the integrity of your artwork.

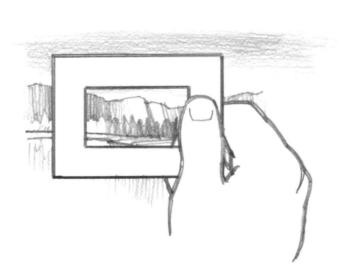

Cropping With a Viewfinder
When held up to the subject, a viewfinder can help you to limit how much of your scenery will be used for your composition. Viewfinders are available at art stores or you can make your own with cardstock.

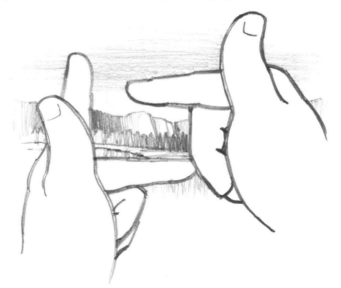

Cropping With Fingers
Another method for cropping a composition is to form a rectangle with your fingers.

Choosing a Format

The overall format for artwork can be horizontal, vertical or square, each offering a different feeling that can be used to enhance the specific subject matter.

Horizontal Format
Using a horizontal format in a composition can express a comforting, pastoral feel.

Vertical Format
A vertical format chosen for a composition can express a bold, forceful feel or emphasize the towering qualities of a subject.

Using a Square Format
The sameness of a square format may detract from the image; however, with the right subject, it can work.

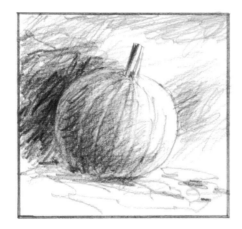

Using Thumbnail Sketches
These small, quick sketches, used for planning a composition, are good for working out problems and comparing ideas before starting a drawing.

Problems and Remedies

Just because you see a subject a certain way doesn't mean you have to draw it that way. The artist is called to enhance the subject and bring the viewer into the picture for an entertaining visual experience. Through the process, an artist will run into problems which should be avoided and remedied early, if possible.

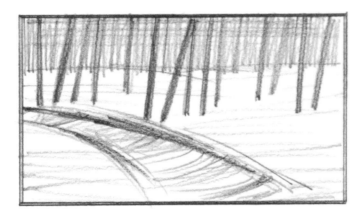

Being Led Astray
Don't place elements which direct the viewer's eye out of the picture.

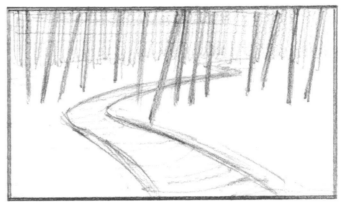

Going the Right Direction
Proper direction of the elements can keep the viewer's interest.

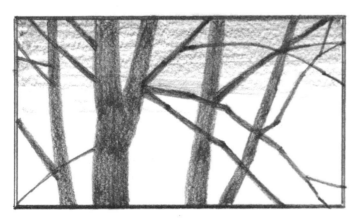

Troubles With Tangents
A tangent is the intersection of two or more elements in a drawing. Though they may occur naturally, tangents can look awkward. In this scene, the branches form unnecessary tangents and create unwanted focal points.

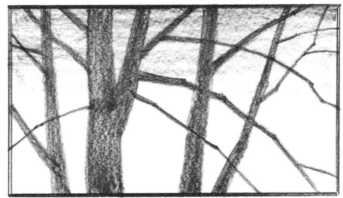

Tangent Remedy
By moving the branches, there are fewer tangents and the scene looks more appealing.

Using Identifiable Forms

Drawing involves communicating identifiable images and forms. Some forms are easier to recognize than others. I find it easier to make a recognizable drawing if the form of the subject is easy to recognize.

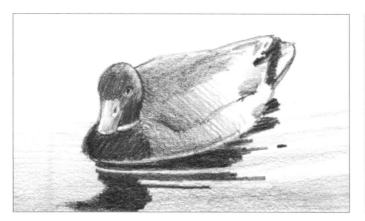

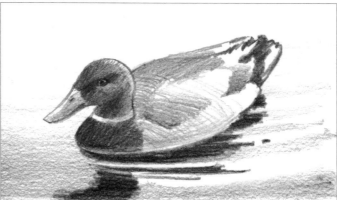

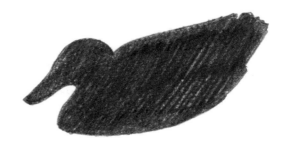

Draw With an Abstract Form

While this is recognizable as a drawing, it is difficult to recognize in silhouette. If this subject isn't drawn just right, the drawing will be hard to identify because the viewer cannot rely on the form for clarity.

Draw With a Recognizable Form

Both the drawing and the outer form of this subject are easy to recognize. Using this subject will more assuredly end with a successful drawing.

Positive and Negative Drawing

Drawings are made up of positive and negative forms. Positive forms are defined by their own shape, whereas negative forms are defined by their surroundings.

Cattails and grass may be drawn positive, as on the left, with their image dark against the white of the paper. They may also be drawn negative, as on the right, with their image created by darkening the area around them.

Cactus Close-Up
Graphite on drawing paper
6" × 9" (15cm × 23cm)

3

Natural Subjects

Observing and studying individual subjects is an important part of the drawing process. Let's build on what we learned in the previous chapters and apply it to the study of each of these subjects. Look for the structure, values and texture of your subject. As you begin, establish the proper proportions and the accurate placement of your lines and shapes. Then add your lights and darks, along with the texture of your subject.

Many inanimate subjects, such as rocks and trees, can be implied in the art rather than drawn as a literal image. However, to be successful in doing this, the light and shadows must be placed so the end result appears authentic.

Rocks my be jagged, layered, smooth or round. When there is nothing to compare them to in a scene, the size or scale of rocks and their formations maybe difficult to determine. Backyard rocks can be studied as smaller versions of larger boulders or rock formations.

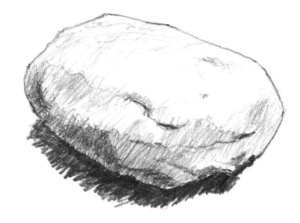

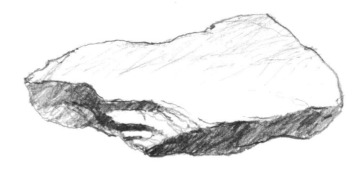

Rocks of Different Sizes
The study of form, light effects and shadows of small rocks can aid in the drawing of larger, more complicated rock formations.

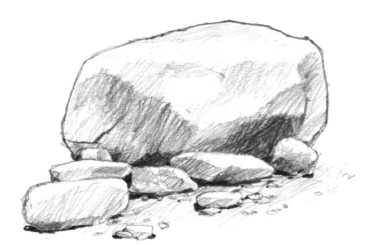

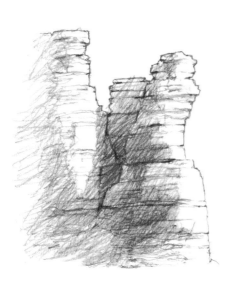

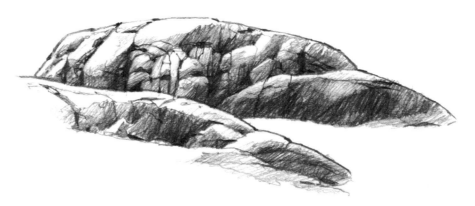

Rock Forms
Rock formations may be big in size but share the same characteristics of smaller rocks.

Rock Formations

DEMONSTRATION

This cluster of rock forms are first drawn as a structural sketch, then the values are added, with the consideration that the light source is coming from the upper left.

Materials

8" × 10" (20cm × 25cm) medium-texture drawing paper

2B graphite pencil

kneaded eraser

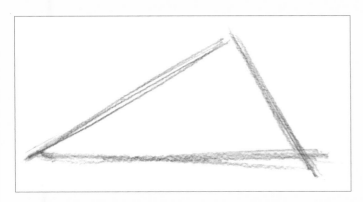

1 Sketch the Basic Shape
Sketch the overall shape of the rock forms with basic lines. With this example, the shape of the rocks forms a triangle.

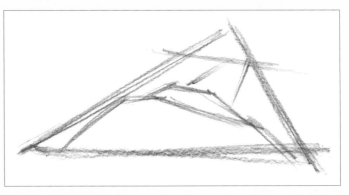

2 Develop the Forms
Develop the rock forms, sketching the largest shapes first, then adding the smaller shapes.

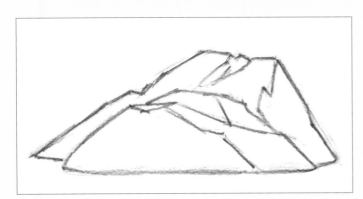

3 Add Detailed Lines
Add detailed lines to the structural sketch to define the shapes of the rock forms. Erase any unwanted lines.

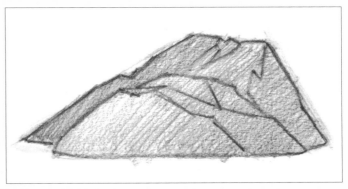

4 Add the Values
Add the lighter, middle and dark values. Add any detailed linework and, if necessary, lighten any areas with a kneaded eraser.

Mountains

Mountains may be thought of as rock formations on a grand scale. The surface of mountains may be exposed rock or covered with trees or snow, but when seen from a distance, they may appear as a single form when in actuality, they are made up of numerous contours.

The Nature of Mountains
Though every mountain may have a unique shape, they are all bound to the same characteristics of light and shadow.

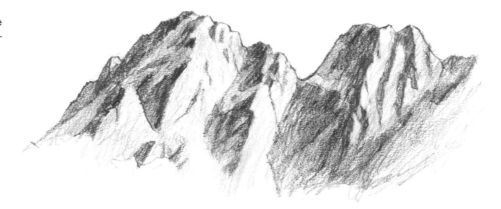

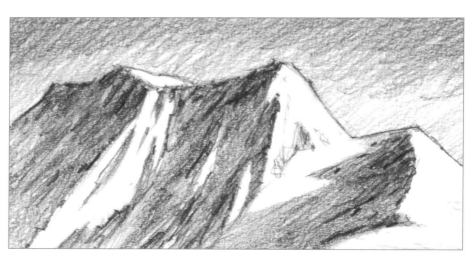

Paper Mountains

Drawing mountains is a study of light and shadow. One exercise to examine the subtle variations of values is to sketch a crumpled piece of paper or cloth that is formed like a miniature mountain.

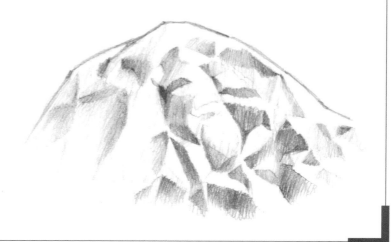

Mountains With Snow

DEMONSTRATION

These Colorado mountains are partially covered with snow that is supported by the layered rock forms. The light source is from the upper right, causing the left sides of the mountains to be in shadow.

Materials

8" × 10" (20cm × 25cm) medium-texture drawing paper

2B graphite pencil

kneaded eraser

1 Sketch the Basic Shapes
Sketch the overall forms of the mountains as basic shapes.

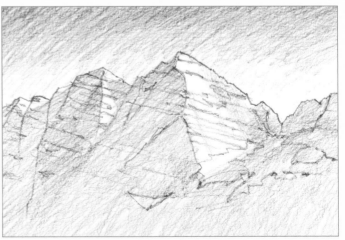

2 Develop the Forms
Develop the forms of the mountains, working in the order of the largest and most noticeable shapes, then sketching the smaller shapes.

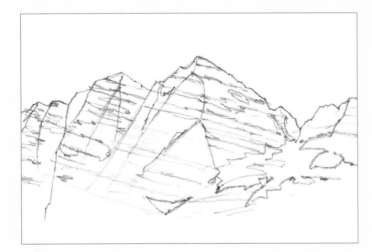

3 Add Detailed Lines
Add detail lines to define the shapes of the structural sketch, including lines for the rock layers and the snow. Erase any unwanted lines.

4 Add Values
Add the lighter, middle and dark values. Adjust by lightening, if necessary, with a kneaded eraser.

The appearance of water is different than solid or opaque elements. It can appear clear or reflective, active or still, and can change depending on how it is viewed and its relationship to other elements.

Water as Transparent

Water may be clear, allowing the elements in the water to be visible, though darker. In this example, the rocks below the water are able to be seen, though they are darker than the rocks that are dry.

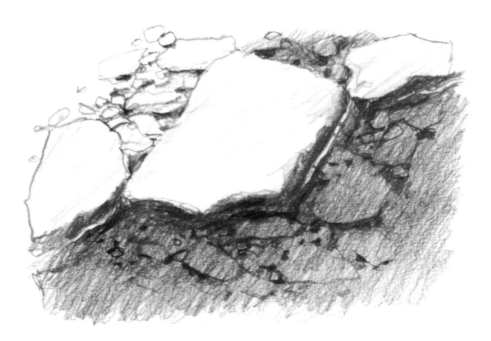

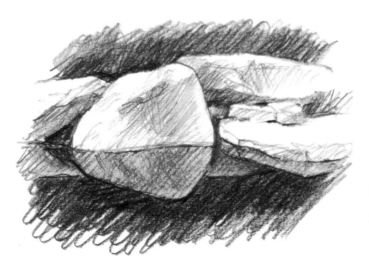

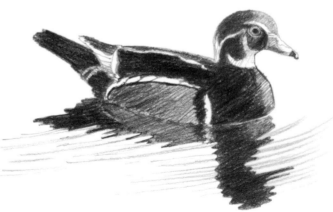

Water as Reflective

A calm surface of water may reflect surrounding elements similar to a mirror's reflection. The reflected image may appear darker than the original elements.

Distorting the Reflection

A reflected image may be distorted by waves or ripples on the surface of the water, such as a duck's reflection distorted by patterned ripples. Add waves and ripples to water to give the scene a sense of motion.

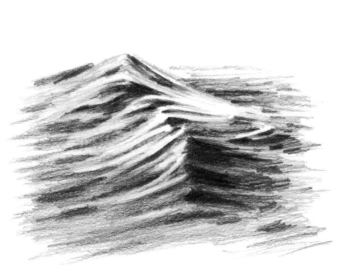

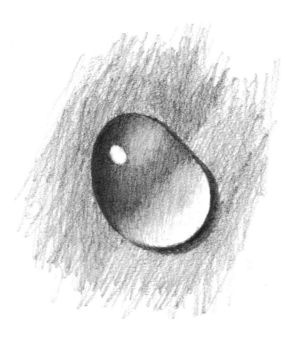

Water as Waves
Large waves reflect their surroundings, but they may also be translucent or even opaque. In this example, the darkest areas in these waves are shadows caused by the shape of the wave blocking the light on the water's surface.

Up Close and Personal
A tiny dew drop on a clover leaf displays the complex characteristics of water. Being clear, it appears differently than an opaque form. With the light source from the upper left, the light reflects off the surface as a highlight on the surface. The light also passes through the dew drop, making it lighter at the lower right. Though it is see-through, there is a shadow at the lower right.

Just Add Water
Water isn't always visible, but it's presence can change the appearance of other elements.

The Dry Look
A smooth rock, when dry, has subtle changes in its values. The light source is from the upper right, causing the bottom left portion of the rock to be dark.

The Wet Look
Doused with water, the rock becomes reflective of its surroundings. A highlight becomes clearly visible and reflected light appears around the edges of the rock, not just along the shadow. Besides having a glossy look, the rock is also darker when it's wet than when it is dry.

Small Waterfall

DEMONSTRATION

The water in this scene displays a range of values from white to middle to dark values. The darkest values are of the shadowed rocks that are on the sides of the falling water. The water at the top and bottom appears calm while the waterfall and foam are more active.

Materials

8½" × 5½" (22cm × 14cm) medium-texture drawing paper

2B graphite pencil

kneaded eraser

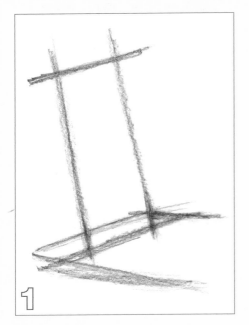

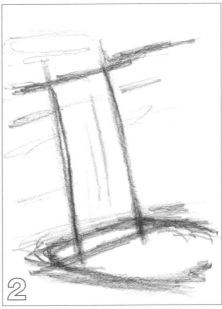

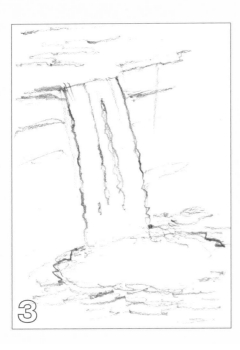

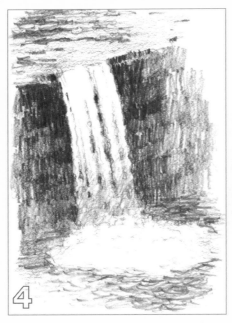

1 Sketch the Basic Shapes
Sketch a rectangle as a basic shape for the waterfall. Sketch the foam area at the base with simple lines.

2 Develop the Forms
Develop the forms of the waterfall and foam, adding curved lines where needed.

3 Add Details
Add details and refine the linework of the structural sketch, erasing any unwanted lines in the process.

4 Add Values
Add the lighter, middle and dark values. Adjust any areas by lightening with a kneaded eraser, if necessary.

Ice and Snow

Because ice and snow are forms of water, their characteristics can also be clear, reflective and opaque.

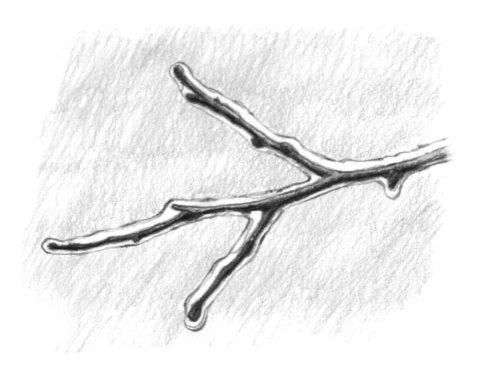

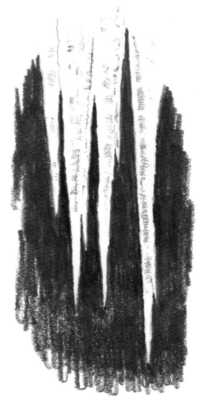

Ice
The ice on a tree branch is clear with a dark outline made up of reflections of surrounding elements.

Icicles
The dark background offers a stark contrast to the clear/white appearance to the icicles that are also reflective.

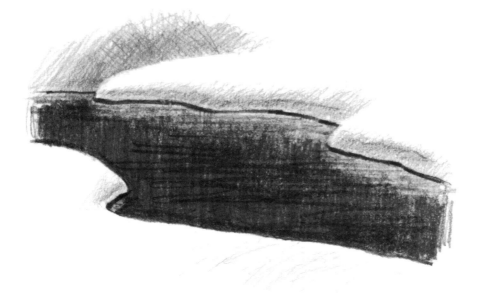

Snow
Snow can appear opaque as in the round contours of snow along the edges of a creek.

Clouds and Skies

Clouds can take on different characteristics. Sometimes they will look translucent, showing that they are made up of water vapors.

Other times they will take on an opaque, almost solid characteristic. Clouds are constantly changing shape and size, which can convey the mood of the weather.

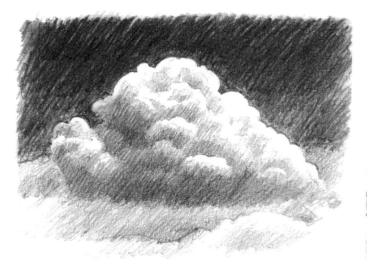

Round and Flat
Cumulus clouds are typically round at the top, with an underside that is flat. They are affected by light and shadow much like forms that are solid, like fluffy cotton balls.

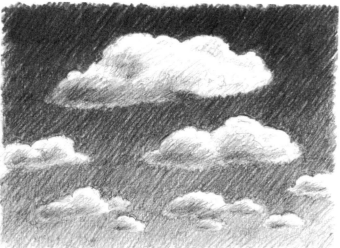

Perspective and Values
Like other forms, clouds are bound to the principles of perspective. With this drawing, the clouds vary in size so that the bigger they are the closer they are to the viewer. The background is intentionally drawn darker at the top because skies are usually darker overhead and lighter closer to the horizon.

Cloudy Characters

When trying to create the shape of a cumulus cloud, remember to keep it loose enough that it doesn't take on the shape of a common form, such as a bunny, dog or dinosaur.

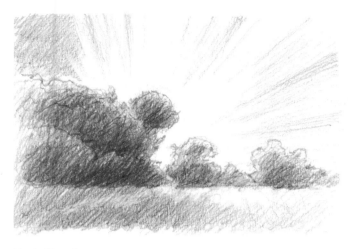

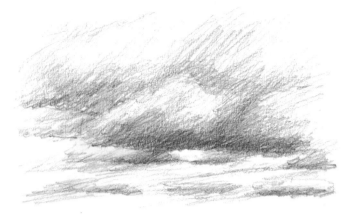

Dark Clouds

Clouds can block the light or obscure the sun and appear dark. The contrast of the clouds against the white sky can give the impression of sunlight.

Sketchy Forms

Some cloud types, such as stratocumulus clouds, may be drawn with sketchy pencil lines in a manner that expresses less distinct forms.

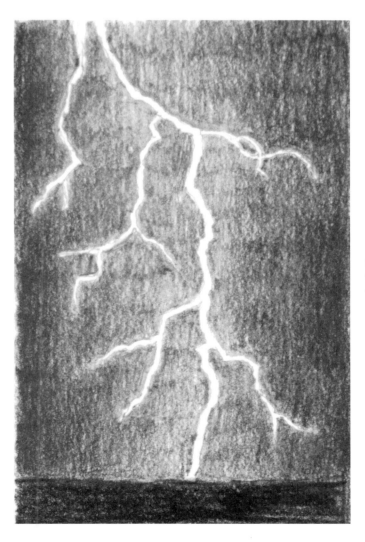

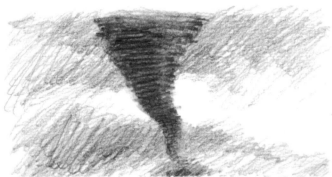

Drama in the Skies

Powerful forces of nature may be displayed in a tornado or with a flash of lightning. A tornado may be drawn as a dark funnel shape against stormy clouds. Lightning may be implied as streaks that branch out against a dark background.

Flowers

Attention to details is a key to capturing the simple elegance of a flower.

Dark Petals on a Light Background
Because the petals of this flower are dark, it can be drawn on a light background. The lights and darks of the petals are placed to bring emphasis to their shape and texture.

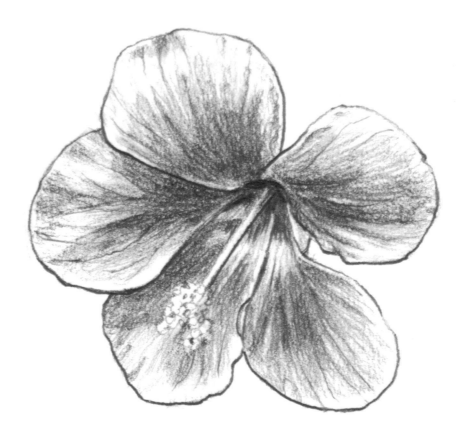

Light Petals on a Dark Background
A dark background behind the light petals of daisies define the shape of their petals.

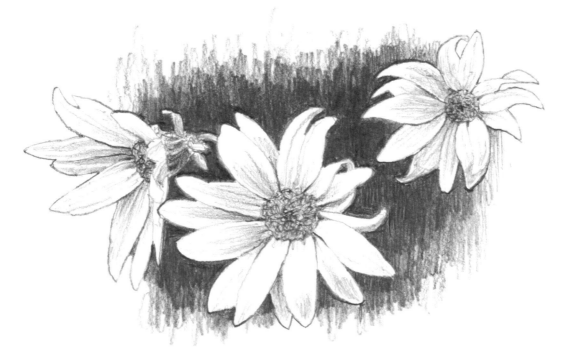

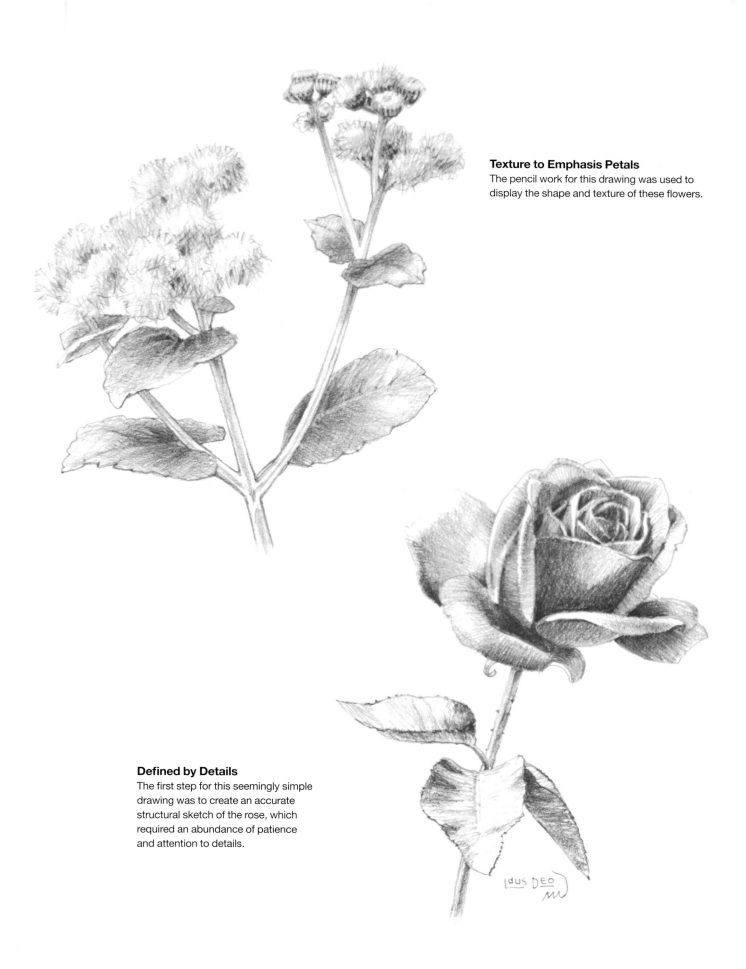

Texture to Emphasis Petals
The pencil work for this drawing was used to display the shape and texture of these flowers.

Defined by Details
The first step for this seemingly simple drawing was to create an accurate structural sketch of the rose, which required an abundance of patience and attention to details.

Coneflower

DEMONSTRATION

The long, curved petals of a coneflower make the overall shape convex. A drawing may include more than one flower, all of which can be drawn with the same process.

Materials
8½" × 5½" (22cm × 14cm) medium-texture drawing paper

2B graphite pencil

kneaded eraser

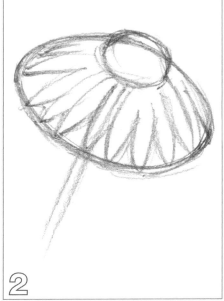

1 Sketch the Basic Shape
Sketch the basic outer shape of the flower and its center with ellipses. Sketch two lines for the stem. Connect the stem lines to the center for drawing accuracy.

2 Develop the Form
Sketch the petals, then add curved lines for the center of the flower to create a convex appearance.

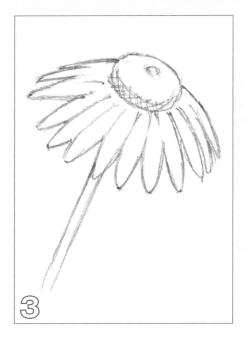

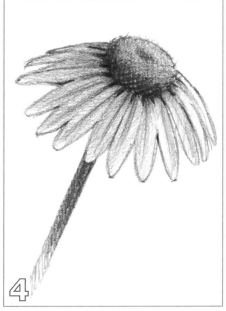

3 Add Detailed Lines and Erase Unwanted Lines
Add detailed lines to the center and to the petals. Erase unwanted lines such as the stem lines underneath the petals.

4 Add the Values
Add the lighter, middle and dark values. Add details to the petals and center. Lighten with a kneaded eraser, if necessary.

To capture the specific personality of a tree, begin by drawing its trunk and overall shape, then the branches, limbs and twigs. The leaves are sketched last, creating the lights and darks according to the placement of the light source.

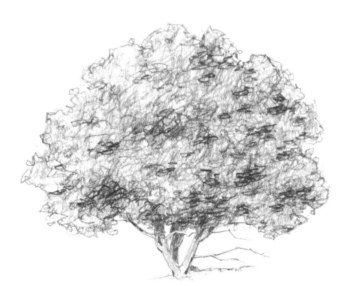

Oval-Shaped Tree
Paying attention to the details of the trunk and shape of this tree's full foliage will help capture the personality of this tree.

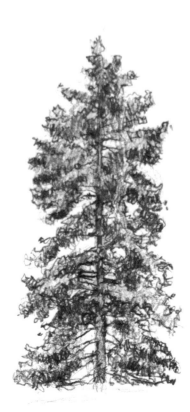

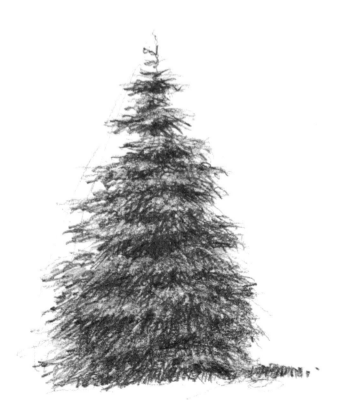

Irregular-Shaped Tree
The oblong shape of this tree, with less foliage and more trunk and branches showing, is what gives this tree its character.

Triangular-Shaped Tree
The pencil strokes for this needle-bearing, triangular-shaped tree are different from a deciduous, leafy tree.

The form of a leafy tree follows the structure of its branches.

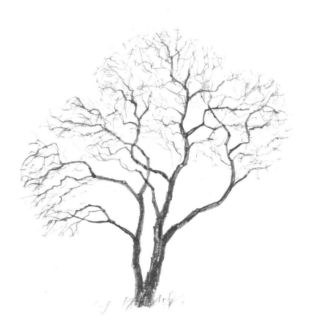

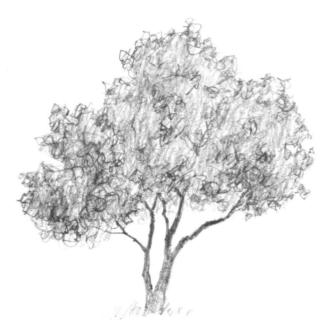

Branching Out
Starting at the base with the trunk, a tree's structure continues up and out with limbs, branches and twigs, each tapering from thick to thin.

True to Form
The placement of the leaves is determined by the tree's supporting structure. Leaves develop at the end of the twigs.

Leaves

The approach to drawing leaves may vary according to the distance the viewer is from the tree. Leaves shown at a distance may be drawn more interpretive, with less detail, than leaves that are shown to be closer to the viewer.

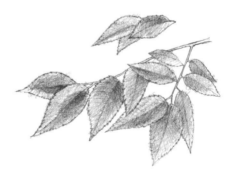

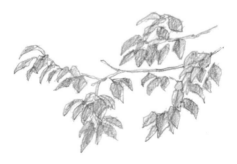

Up Close
When drawn up close and large, details to the leaves' form and structure may be added.

Smaller and Distant
When the leaves are viewed more at a distance, the leaves appear smaller and details are minimized. For this drawing, a simple structural sketch can be made for the branches and leaf placement, then the leaf forms can be added through contour drawing with values added in place of the finer details.

Loose and Interpretive
This cluster of oak leaves was done as a contour drawing with values added. The leaves were drawn as a group rather than individually. The result is a more interpretive representation rather than a literal drawing of the subject.

Tree Bark, Trunks and Stumps

One aspect of improving drawing skills is to take time to observe the details around you. As you walk through a park, notice that the texture of tree trunks is as unique as the individual species of trees. Capturing that unique texture of bark is part of the fun in drawing trees.

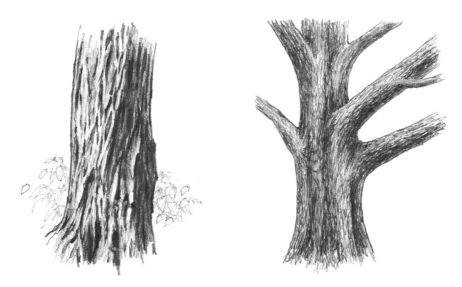

Bark and Trunks
The texture of tree bark may be as individual as the species.

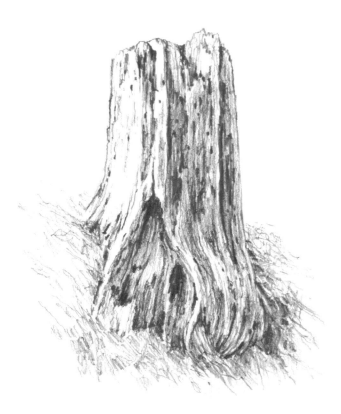

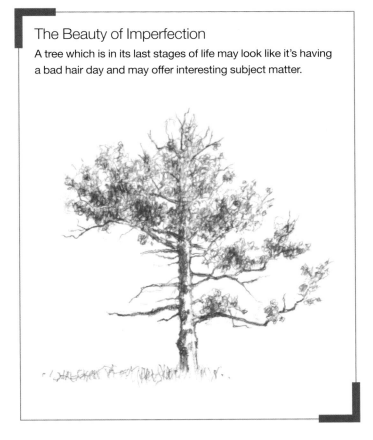

The Beauty of Imperfection
A tree which is in its last stages of life may look like it's having a bad hair day and may offer interesting subject matter.

Tree Stumps
Absent of bark, the exposed wood of a rotting tree stump is rich with texture because of its many holes and recesses.

Palms and Cacti

Palms and cacti are very different in appearance to other types of trees. Palm trees have a mass of leaves at the top while cacti are made up of solid forms, absent of leaves. You may find palms and cacti to be a bit easier than other types of trees to draw.

Palm Trees
Palm trees have long feather-shaped leaves that grow directly from the top of the trunk.

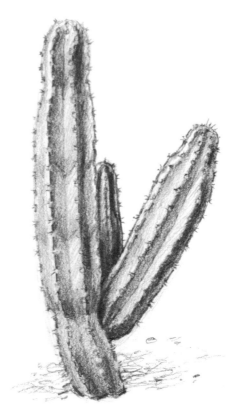

Cacti
Unusual in appearance from other plants, cacti have sharp spines instead of leaves.

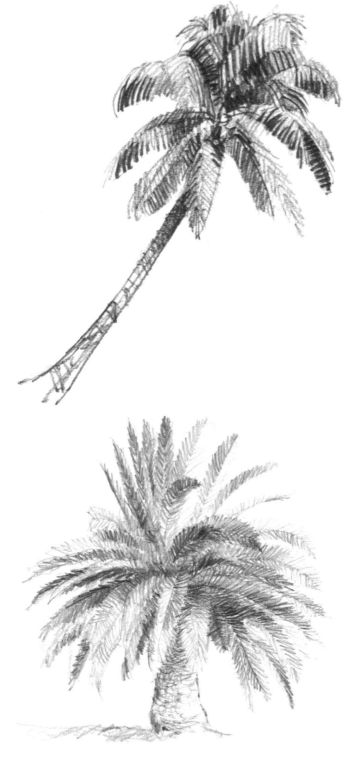

Tree

DEMONSTRATION

The structure of the branches and outer form can be drawn before the leaf shapes.

Materials

8½" × 5½" (22cm × 14cm) medium-texture drawing paper

2B graphite pencil

kneaded eraser

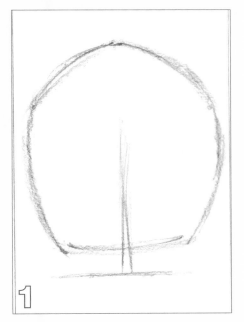

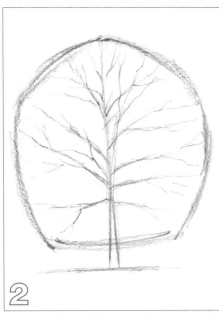

1 Sketch the Basic Shape
Sketch the trunk, baseline and outer form to create the basic shape of the tree.

2 Add Limbs and Branches
Add the limbs and branches to the main trunk, sketching them to be more vertical as the branches approach the top of the tree.

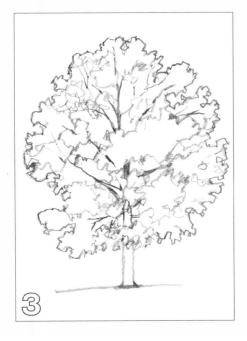

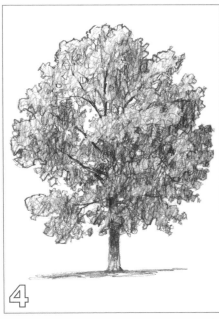

3 Develop Leaf Forms
Develop the forms of the leaves and erase the unwanted limbs and branches that are obscured by the leaves.

4 Add Values
Add the lighter, middle and darker values and, if necessary, lighten with a kneaded eraser.

Insects

The close-up world of insects provides another dimension of interest to your drawings. Study a subject through detailed reference photos to increase your observational skills and add credibility to a drawing.

Butterfly in Profile
The dark framework along with the graduation of values within the wing identify this butterfly as a monarch.

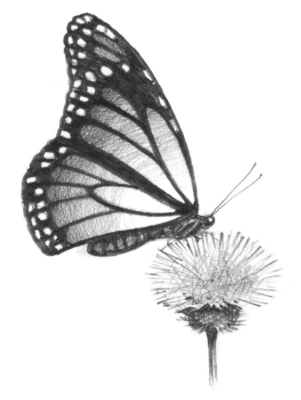

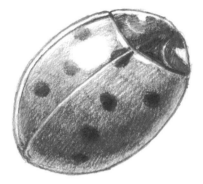

Ladybug
The smooth outer casing of a ladybug can be drawn as a glossy surface, which has both reflective and three-dimensional qualities.

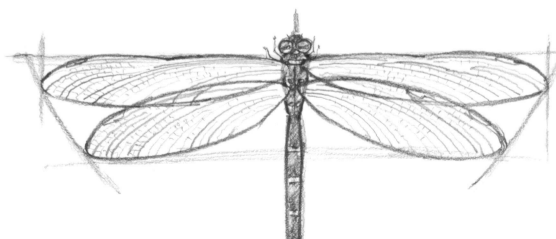

Dragonfly Symmetry
The form of a dragonfly is drawn with a central body that is perpendicular to its symmetrical wings.

Butterfly

DEMONSTRATION

The complex form of the butterfly is easier to draw when first sketched with simple geometric shapes. Butterflies vary in appearance; however, the process for drawng them can be the same.

Materials

5½" × 8½" (14cm × 22cm) medium-texture drawing paper

2B graphite pencil

kneaded eraser

1 Sketch the Basic Shape
Sketch a rectangle with a center line and then add more lines for a basic symmetrical shape.

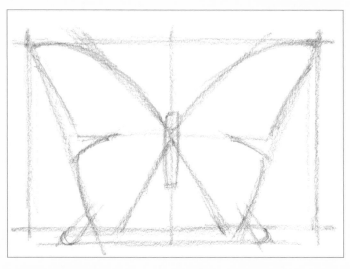

2 Develop the Form
Develop the form of the butterfly, including the wings, thorax and abdomen.

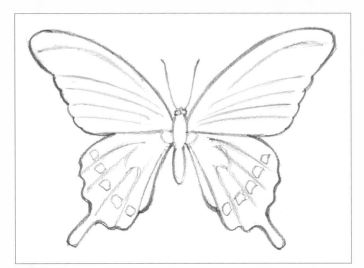

3 Add Detailed Lines and Erase Unwanted Lines
Add lines detailing the inner and outer forms, erasing unwanted lines throughout the process.

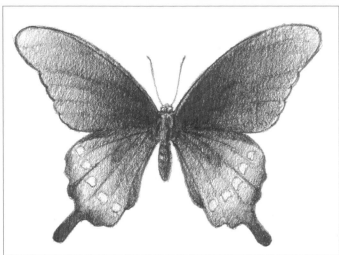

4 Add Values
Add the lighter, middle and dark values, lightening with a kneaded eraser, if necessary.

To be walking quietly in a forest and happen upon a deer is an amazing experience. Both the deer and observer are startled, looking at one another for an instant before deciding to move on.

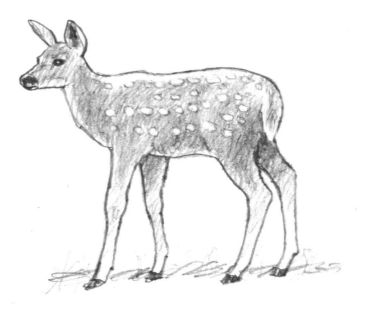

Fawn
The accuracy of proportioning of the features of this deer create the image that it is a fawn rather than a full grown deer.

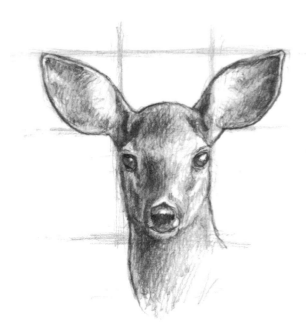

Using a Grid
A lightly drawn grid was used to capture the symmetrical features of the head of this fawn.

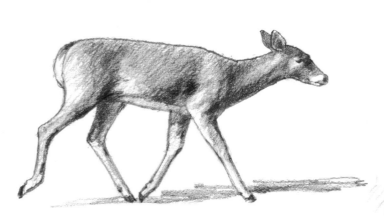

A Deer Walking
The shading emphasizes the form of this deer as it is walking.

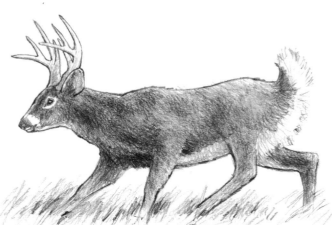

Hidden in the Grass
If you find hooves troublesome to draw, the deer can always be placed in tall grass, which hides the hooves.

Deer

DEMONSTRATION

The head and antlers, viewed straight on, can be drawn symmetrically. The basic shape can be sketched as a straight vertical with horizontal lines. More fluid lines are developed throughout the drawing process.

Materials

10" × 8" (25cm × 20cm) medium-texture drawing paper

2B graphite pencil

kneaded eraser

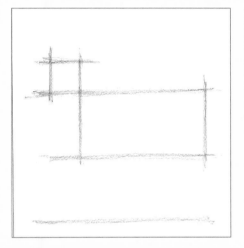

1 Sketch the Basic Shape
Proportion and sketch a rectangle for the body and a baseline on which to rest the hooves. Sketch lines for the top and sides of the head.

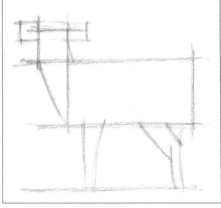

2 Define the Animal Form
Add lines for the neck and torso area and the closer front and rear legs. Sketch squares on the side of the head for the placement of the ears.

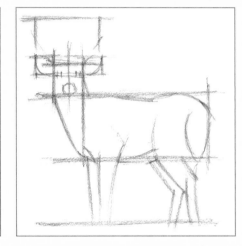

3 Develop the Deer
Sketch lines for the other two legs and the tail. To keep elements symmetrical, sketch a center line for the face, lines for the eyes and a circle for the snout. Add lines to place the antlers and develop the form of the body.

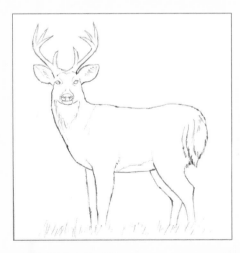

4 Add Detailed Lines
Add details and refine the overall form, erasing unwanted lines throughout the process.

5 Add Values
Add the different values, use a kneaded eraser to lighten some areas, if needed.

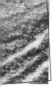

Paying attention to proportions and shapes will help you to capture the personalities of these small critters. After you have established the structure, use different pencil strokes to add texture, creating the fur.

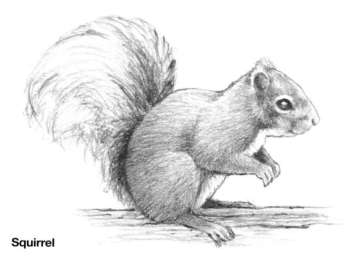

Squirrel

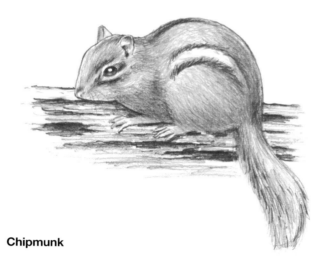

Chipmunk

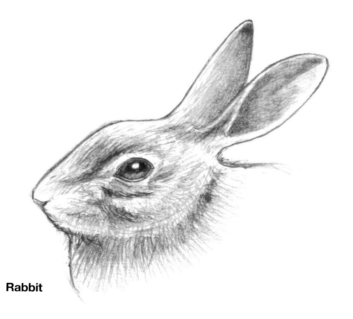

Rabbit

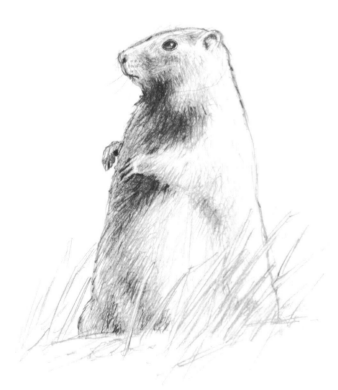

Groundhog

Don't Go Nuts Over Squirrels

The basic shapes and lines of some subjects may be hard to visualize, especially animals like squirrels. One method to find the basic lines and shapes of a subject is to tape a sheet of tracing paper over the reference photo and trace the basic shapes of the subject. The lines and shapes of the tracing can be used for observation when doing the structural sketch.

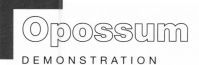

Opossum
DEMONSTRATION

If you live in eastern North America, you are no doubt familiar with the opossum, a nocturnal marsupial with a rat-like tail. The basic shapes of the body and head can be sketched as circles. The legs and feet are concealed in this picture so they don't have to be drawn.

Materials

5½" × 8½" (14cm × 22cm) medium-texture drawing paper

2B graphite pencil

kneaded eraser

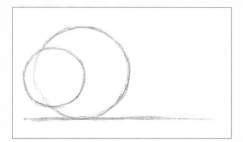

1 Sketch the Basic Shapes
Sketch the horizontal baseline, then sketch a large circle as the basic shape of the body, then a smaller circle as the shape of the head.

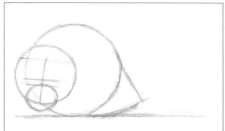

2 Add to the Basic Shapes
Add to the circles a center face line, lines for the eyes and ears, a smaller circle for the snout and two lines for the back of the opossum.

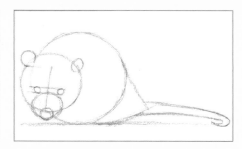

3 Add Features
Add features to the basic shapes including eyes, ears, nose and tail.

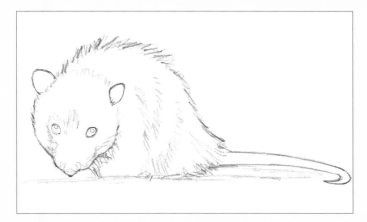

4 Add Lines and Erase Unwanted Lines
Add details including lines for the direction and shading of the fur. Erase any unwanted lines with the kneaded eraser.

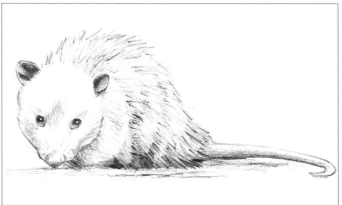

5 Add Values
Add values, mostly straight lines to indicate fur. Lighten with a kneaded eraser, if necessary.

The shape of a bird is different depending on whether it is sitting or active. Pay attention to its overall shape to find the foundation for a successful bird drawing.

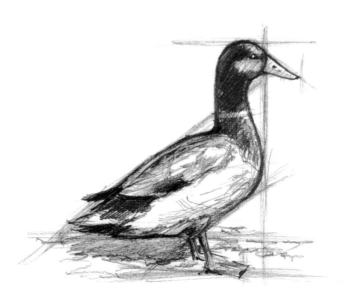

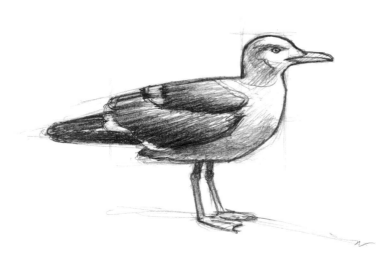

Mallard Duck, Seagull
Simple geometric lines and shapes were used to work out the structure of these birds.

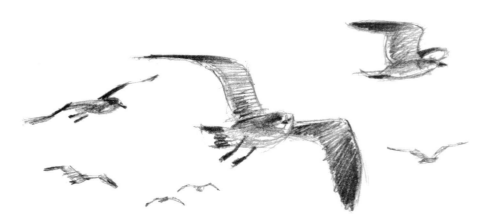

In Flight
The sketchy nature of the pencil strokes used for this drawing helps to create the feel of seagulls in flight.

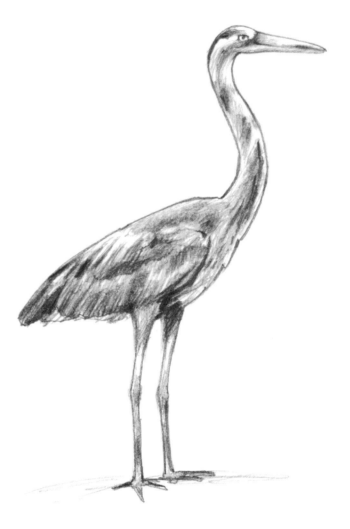

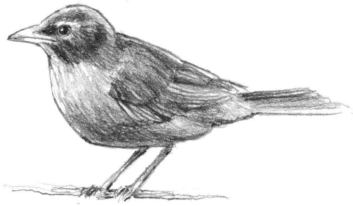

Great Blue Heron and Robin
Detailed pencil strokes were applied to create the texture that defines the body and feathers of these birds.

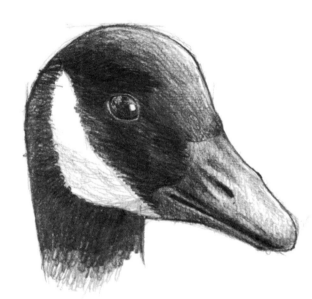

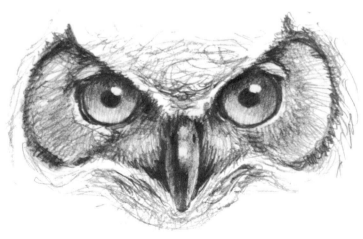

Eye to Eye
Attention to detail while drawing the eyes brings these birds to life. Notice the highlights and reflective qualities of the eyes. The goose also has a light gray perimenter around the eye, distinguishing it from the dark face.

Goose

DEMONSTRATION

The Canada goose is a pleasant subject to draw with its recognizable form and distinctive markings. Attention to detail is important when you are drawing features such as the eyes and feathers.

Materials

5½"× 8½" (14cm × 22cm) medium-texture drawing paper

2B graphite pencil

kneaded eraser

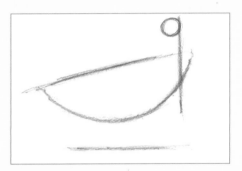

1 Sketch Basic Shapes
Sketch the basic shapes of the form of the bird starting with an arc with a line at the top for the body. Add a vertical line on the right to determine the placement of the circle for the head along with a horizontal baseline for the feet.

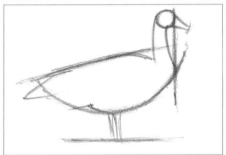

2 Develop the Form
Add the neck, bill and legs and shape the body to develop the form of the bird.

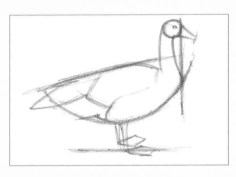

3 Start to Add Details
Start adding the details including the eye and feet and the forms of the feathers.

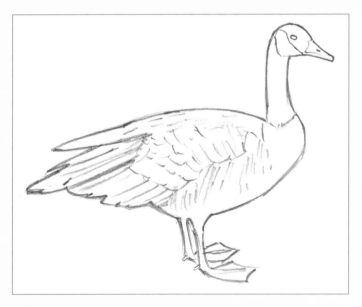

4 Create Details and Erase Unwanted Lines
Add more details, including feathers. Refine the outer form and erase unwanted lines.

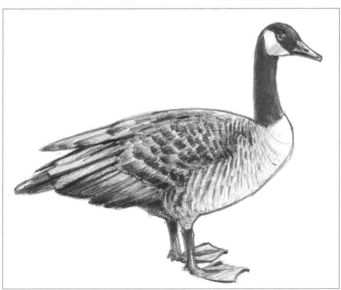

5 Add Values
Add the wide range of values. Use a kneaded eraser to lighten any areas.

Eagle in Flight

DEMONSTRATION

Large predatory birds have a regal beauty that is inspiring. The tapering of the wings and the off-center placement of the body contribute to the impression that one wing is farther away than the other.

Materials

5½"× 8½" (14cm × 22cm) medium-texture drawing paper

2B graphite pencil

kneaded eraser

1 Sketch the Basic Shape of the Wings
With curved and straight lines, sketch the basic shape of the outstretched wings.

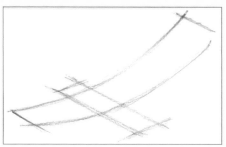

2 Sketch the Shape
Sketch a rectangle for the basic shape of the body, including the head and tail feathers. Because the subject is shown in perspective, the placement of the body appears farther to the left than it does to the center of the wings.

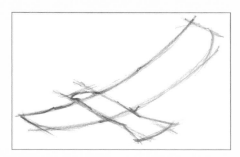

3 Develop the Form
Develop the overall form of the wings, head, body and tail.

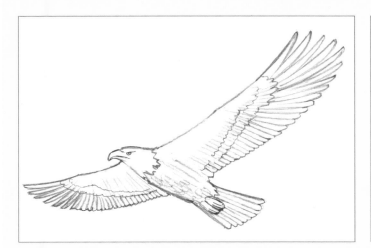

4 Create Details and Erase Unwanted Lines
Refine the lines and add details including the feathers, which fan out at the ends of the wings. Erase any unwanted lines.

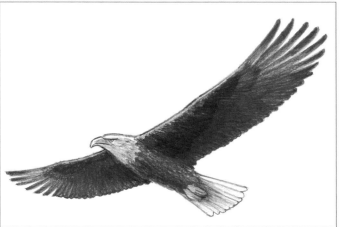

5 Add Values
Add the values throughout the form of the eagle. Lighten any areas with a kneaded eraser, if necessary.

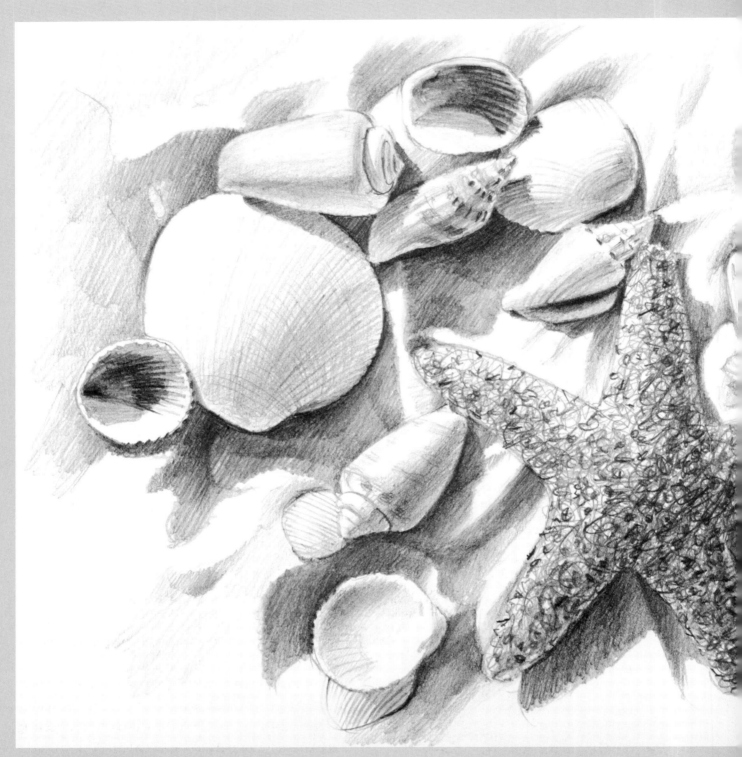

Shells Along the Beach
Graphite pencil on drawing paper
9" × 12" (23cm × 30cm)

4

Let's
Draw!

There are two types of people in this world: those who like to work through a book from beginning to end and those who like to skip around. Whichever category you fall into, this book is written with you in mind.

These demonstrations are set up to begin with the structural sketch, then values will be added to complete a finished drawing.

When developing the structural sketch, start with light pencil strokes, gradually darkening the linework as the image becomes more definite. At this stage, leaving incorrect pencil strokes, rather than erasing them, can help to determine the correct placement of structural lines.

Remember to refer back to earlier demonstrations for step-by-step instructions of individual subjects as you work through these lessons.

Take pride in your artwork. It is unique and so are you. Sign and date your sketches and drawings so that you'll be able to see a progression of your skills. Also, by setting aside your artwork and viewing it at a later date, you are likely to see it with a renewed appreciation.

Rocks

Nature provides many simple subjects that are interesting to draw. For this demonstration, the structural sketch can be made directly onto the drawing paper or done on a separate sheet of paper, then traced or transferred onto the drawing paper to avoid unwanted lines and erasing. Sketch the whole rock, not just the part that is seen, so that you can be more accurate with the shape of the rocks. Duplicating the size and shapes of the rocks aren't as important as keeping the light and shadows consistent.

The light source is coming from the upper right, causing the rocks to be lighter at their upper right and darker at their lower left. The dark regions are well defined and can be established at the beginning of the values stage.

The values of your drawing can be compared to the finished demonstration in the book using your value scale.

Materials

Pencils
2B graphite
4B graphite
8B graphite

Paper
6" × 9" (15cm × 23cm) rough-texture drawing paper

Other Supplies
kneaded eraser
value scale

Optional Supplies
6" × 9" (15cm × 23cm) fine or medium-texture sketch paper
lightbox or transfer paper

RELATED TOPICS
• Implying Texture
• Rocks and Rock Formations
• Gauging Values

 Start the Structural Sketch
With a 2B pencil, start the structural sketch with the biggest rock, paying attention to its shape and its placement on the paper.

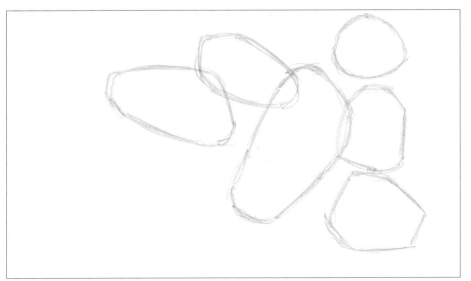

2 Add More Rock Shapes
Sketch the rocks that are on top of other rocks. Though the full shape of some of the rocks may be obscured by other rocks, sketching their complete shape will ensure accuracy.

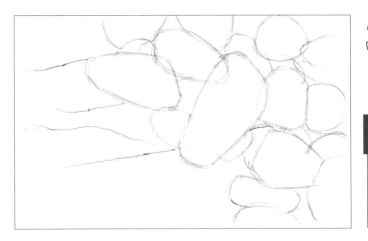

Continue to Add Rock Shapes

Add more rock shapes until all are sketched in. Add lines for showing the cracks and crevices.

Erase, Trace or Transfer

To avoid erasing on the drawing paper, work up the structural sketch on a sheet of sketch paper, then trace or transfer the structural sketch onto the drawing paper, leaving out any unwanted lines.

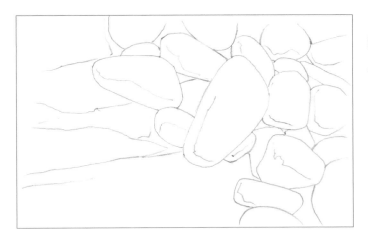

Erase or Transfer and Add Details

Erase any unwanted lines or transfer the sketch onto drawing paper by tracing it if you are working from a separate sketch. Add lines indicating shadowed regions on the individual rocks.

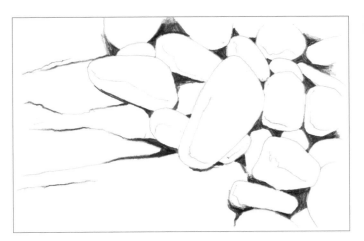

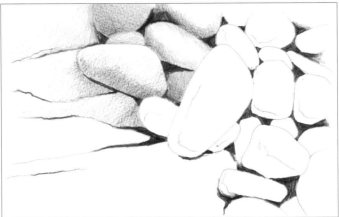

Add Darkest Regions

With an 8B pencil, place the darkest regions using the handwriting grip for controlled linework. Avoid drawing a heavy line around the rocks. Look for the darkest, most recessed places and add darks according to what you see.

Start Adding Light and Middle Values

With a 4B pencil, start adding middle values with a pencil grip that places the lead flat against the paper's surface for wide, smooth linework. You may want to rest your hand on a slip sheet to avoid smearing the paper surface.

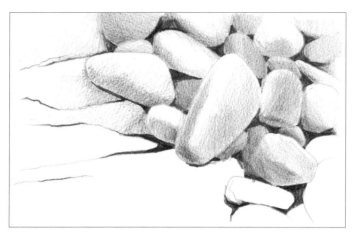

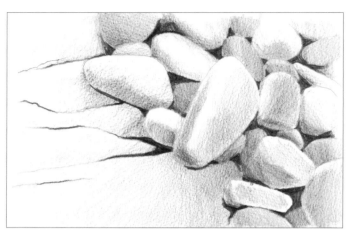

7 Continue Adding Light and Middle Values
Continue adding the light and middle values. The rocks that rest below other rocks may appear darker.

8 Finish Adding Light and Middle Values
Finish adding the light and middle values to the rock surfaces.

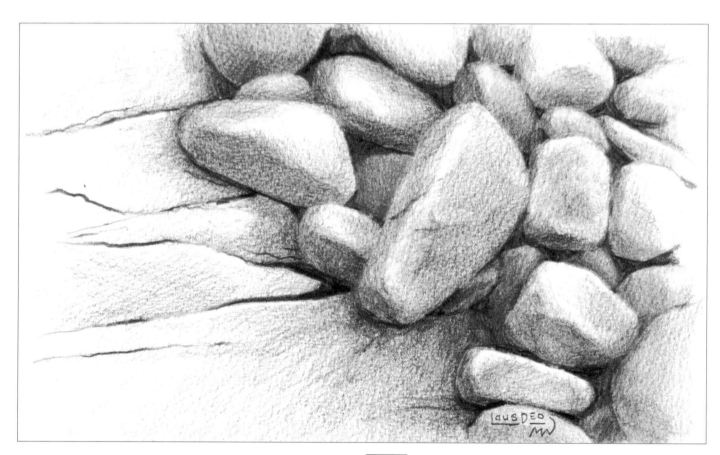

9 Darken and Lighten to Finish the Drawing
Make adjustments, darkening some areas with 4B and 8B pencils and lightening other areas with a touch of a kneaded eraser. Use your value scale to compare the lights and darks. Add your signature to the front and the date on the back.

Don't Smear It
Rest your hand on a separate piece of paper when adding the values to keep from smearing the graphite of your drawing.

Rocks
Graphite pencil on drawing paper
6" × 9" (15cm × 23cm)

Sunflower

The contrast of the dark background against the light petals causes the flower to look bright. The background itself can be drawn to express values rather than distinct forms.

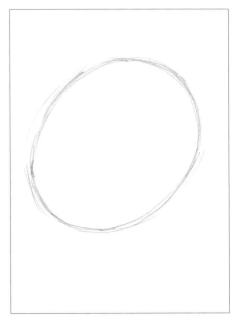

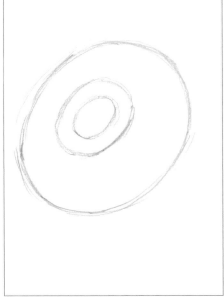

Materials

Pencils
2B graphite
4B graphite
8B graphite

Paper
9"× 6" (23cm × 15cm) medium-texture drawing paper

Other Supplies
kneaded eraser
value scale

Optional Supplies
9"× 6" (15cm × 23cm) fine or medium texture sketch paper
lightbox or transfer paper

1 Sketch the Flower's Outer Shape
With a 2B pencil, start the structural sketch of the flower with an elipse for its outer shape. This will be a guide for the outermost tips of the petals.

2 Sketch the Two Central Ellipses
Sketch the larger of the two central ellipses, then the smaller one.

RELATED TOPICS
- Scribbling
- Blocking In With Basic Shapes
- Values
- Gauging Values

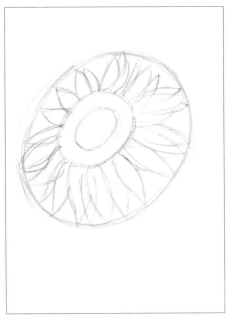

3 Sketch the Petals
Sketch the shapes of the individual petals, going from the center to the outer shape. Some of the petals will overlap others. Though all of the petals remain within the outer ellipse, they vary in shape and size.

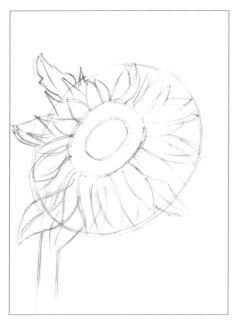

4 Sketch Leaves and Stalk
Sketch the surrounding leaves and the stalk of the flower.

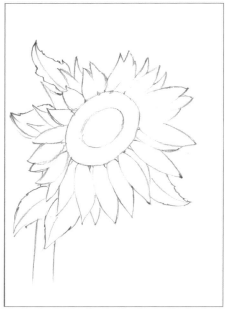

5 Erase or Transfer to Drawing Paper
Erase unwanted lines or transfer the image onto drawing paper, leaving out any unwanted lines.

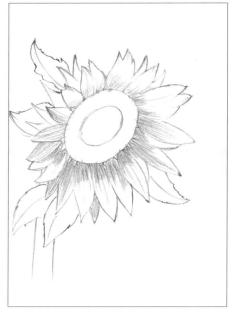

6 Add Values to the Petals
With the 2B pencil, start adding values by lightly shading some regions of the petals. The pencil lines can follow the direction of the petals.

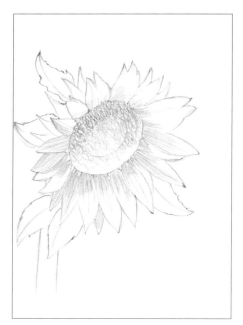

7 Add Values to the Center
Add light and middle values to the center of the flower with scribbly pencil lines.

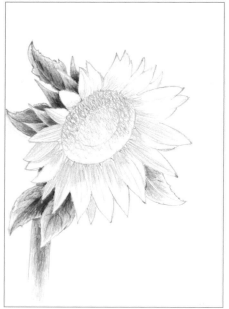

8 Add Values to the Leaves and Stalk
Continuing with the 2B pencil, add light, middle and dark values to the leaves and stalk.

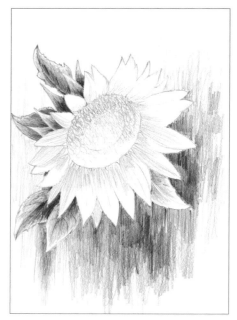

9 Darken the Background
With a 4B pencil, darken the area of the background against the flower at the lower right.

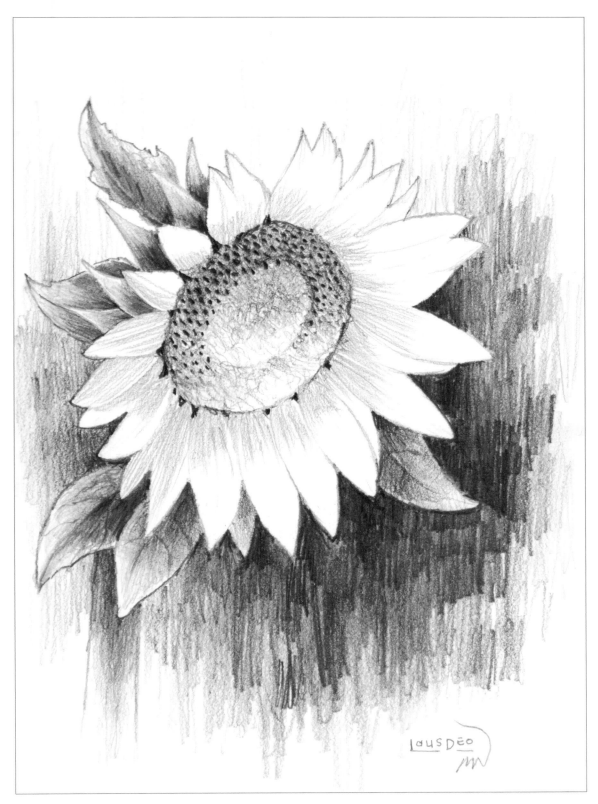

10 Add Darks and Details

With the 8B, 4B and 2B pencils, add darks and details. Compare the lights and darks with a value scale and darken with pencil or lighten with a kneaded eraser, if necessary. Add your signature to the front and the date on the back.

Sunflower
Graphite pencil on drawing paper
9" × 6" (23cm × 15cm)

Shells Along the Beach

Seashells can bring to mind vacationing by the beach with a warm, gentle breeze and the sound of the waves pounding on the shore. However, if you aren't near the ocean but you like the subject matter, consider buying items such as shells, a starfish and sand from a craft store to make up your own composition.

The structural sketch starts with the basic shapes of the larger elements. The starfish is a big circle to indicate its outer perimeter, a smaller circle for its center, then the lines connecting the circles to form the legs. The light source for this scene is coming from the upper left, casting shadows of the objects to the lower right.

Materials

Pencils
2B graphite
4B graphite

Paper
9" × 12" (23cm × 30cm) medium-texture
drawing paper

Other Supplies
kneaded eraser
value scale

Optional Supplies
9" × 12" (23cm × 30cm) fine or medium texture sketch paper
lightbox or transfer paper

RELATED TOPICS

- Shading and Texture
- Gauging Values
- Light and Shadow
- Composition

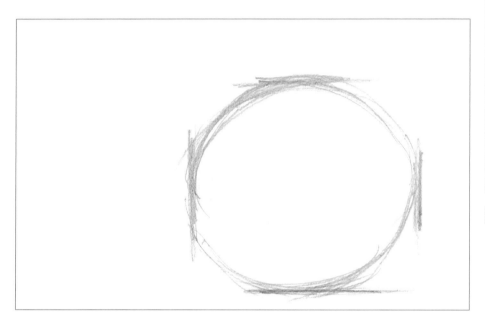

1 Begin the Structural Sketch
With a 2B pencil, begin the structural sketch with the outer form of the starfish, first proportioning its width and height, then sketching an overall circle.

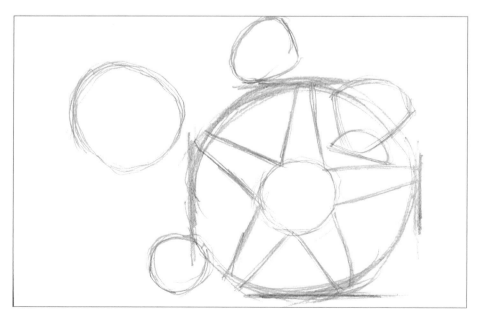

2 Create the Starfish Form
To create the starfish, sketch a circle for its center, then connect the inner circle with the outer circle with lines that will make the legs. Start sketching the most prominent shell using basic shapes.

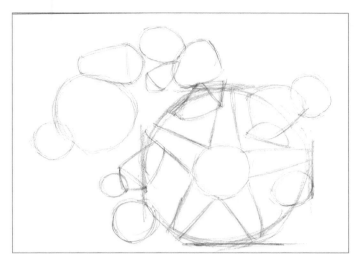

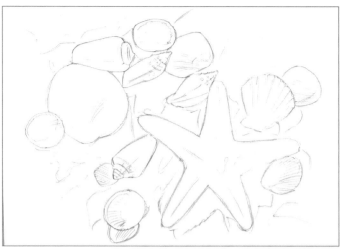

3 **Add the Other Shells**
Sketch the other shells with basic shapes.

4 **Erase or Transfer and Add Details**
Erase unwanted lines or transfer the sketch onto the drawing paper, leaving out the unwanted lines. Add details, including lines to place the shadows.

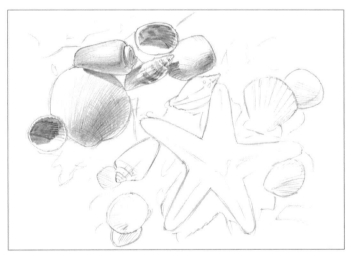

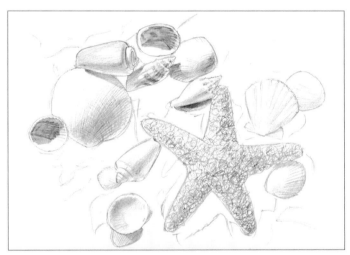

5 **Start Shading the Objects**
Continuing with the 2B pencil, shade the seashells. If you are right handed, start at the upper left to avoid unwanted smearing, or if you are left handed, start with the upper right. The 4B pencil may be used for the darker areas.

6 **Continue Shading**
Continue shading the seashells and starfish. Scribbling can be used to imply the texture of the starfish.

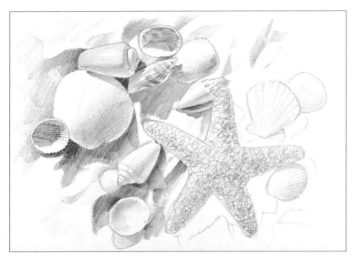

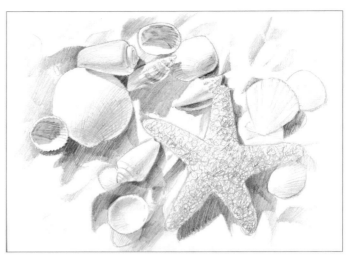

7 Begin Shading the Sand
With the 2B and 4B pencils, begin shading the sand. The values used for the sand can be drawn to contrast with the shells and starfish.

8 Complete Shading of the Sand
Complete the initial shading of the sand around the seashells and starfish.

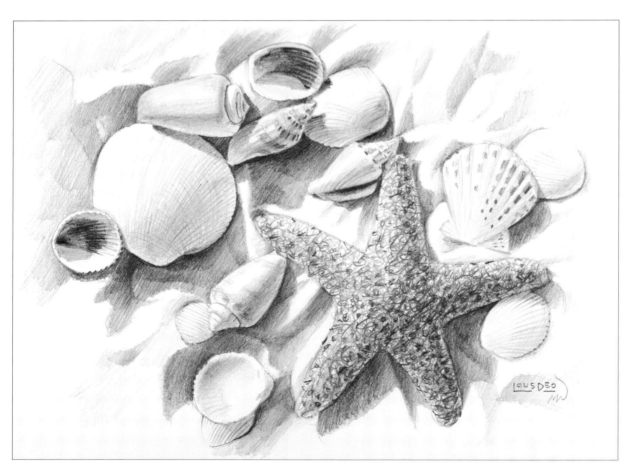

9 Finish the Drawing
Make adjustments and add details, darkening some areas with pencil and lightening others with a kneaded eraser. Compare the lights and darks with a value scale. Add your signature to the front and the date on the back.

Shells Along the Beach
Graphite pencil on drawing paper
9" × 12" (23cm × 30cm)

Tree Trunk and Roots

You will find subject matter for drawing right at your feet, such as a tree trunk with a tangle of exposed roots. The exact placement is not as important as the implied form of the gnarly roots that taper the farther they extend from the trunk.

The light source is from the upper left, causing the tree trunk and roots to be shadowed to their lower right areas. Add some whimsy by drawing a little arched gnome door at the crook of the tree trunk.

Materials

Pencils
2B graphite
4B graphite
6B graphite

Paper
9" × 12" (23cm × 30cm) medium-texture drawing paper

Other Supplies
kneaded eraser
value scale

Optional Supplies
9" × 12" (23cm × 30cm) fine or medium-texture sketch paper
lightbox or transfer paper

RELATED TOPICS
- Shading and Texture
- Gauging Values
- Light and Shadow
- Composition

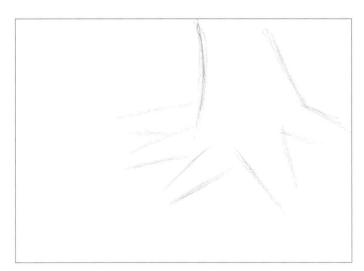

1 Start the Structural Sketch and Add Roots
With a 2B pencil, start the structural sketch of the tree trunk, which is the biggest, most prominent element. Add the center tree root, then add the wide roots that are directly connected to the tree trunk.

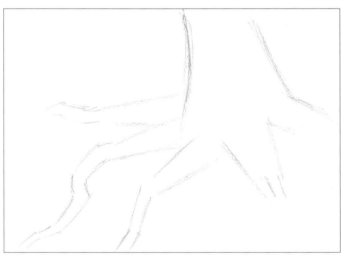

2 Lengthen the Tree Roots
Lengthen the previously sketched roots, tapering the shapes throughout the process.

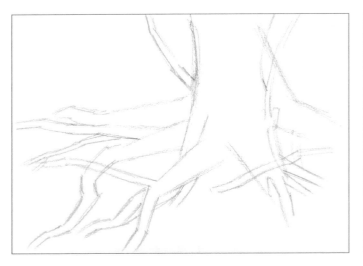

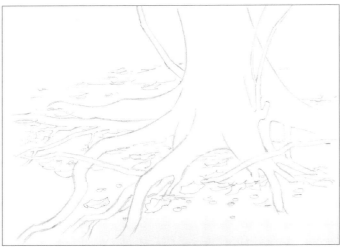

3 Add Smaller Roots and Branches
Add the smaller offshoot tree roots and branches.

4 Erase or Transfer and Add Details
Erase any unwanted lines or transfer the structural sketch onto drawing paper. Add detailed elements such as leaves and rocks.

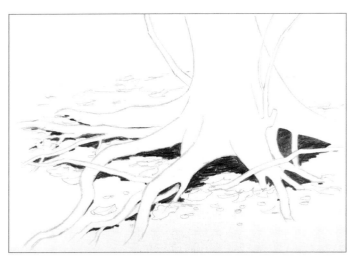

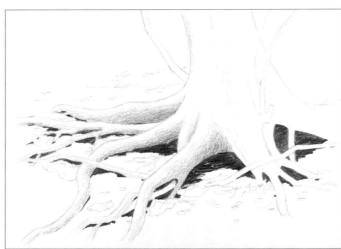

5 Begin the Darkest Values
With a 6B pencil, draw the darkest values which appear in the recessed areas.

6 Add Values to the Trunk and Roots
With a 4B pencil, start adding the light and middle values to the tree trunk and roots.

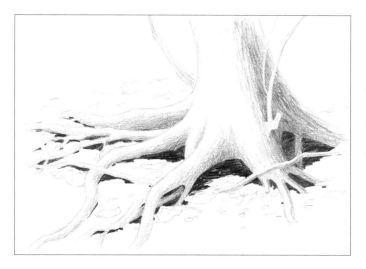

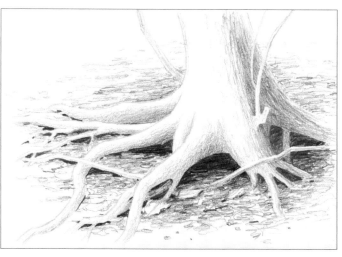

7 **Continue Adding Values**
Continue adding the light and middle values to the trunk and roots.

8 **Develop the Surounding Elements**
Add values to the elements surrounding the tree trunk and roots with the 4B pencil. Much of it can be done with horizontal scribble linework.

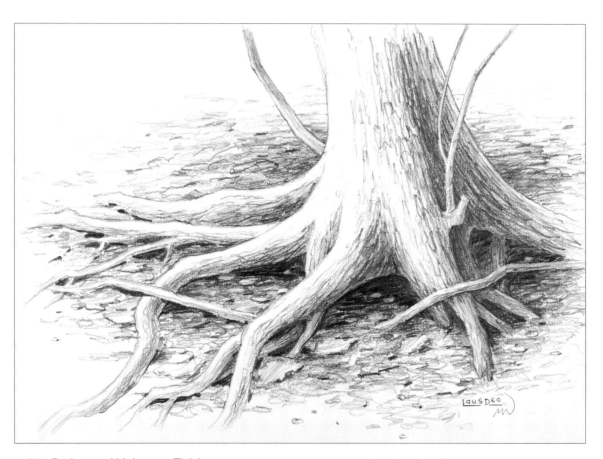

9 **Darken and Lighten to Finish**
With a 2B, 4B and 6B pencils, add details such as rocks, leaves and tree bark lines. Darken some areas and lighten some with a kneaded eraser as needed. Compare the lights and darks with a value gauge. Add your signature to the front and date the back.

Tree Trunk and Roots
Graphite pencil on drawing paper
9" × 12" (23cm × 30cm)

Flowers and Butterfly

It may be easier to sketch the butterfly and flowers separately, then combine their images on the drawing paper after their forms have been worked out. The background may be shown as values, lighter at the top left and darker at the lower right. The light source for this scene is from the upper right.

Materials

Pencils

2B graphite

4B graphite

6B graphite

Paper

8" × 10" (20cm × 25cm) medium-texture drawing paper

Other Supplies

kneaded eraser

value scale

Optional Supplies

8" × 10" (20cm × 25cm) fine or medium-texture sketch paper

lightbox or transfer paper

RELATED TOPICS

• Flowers

• Butterfly

1 Sketch the Basic Shape of the Middle Flower
With a 2B pencil, sketch the basic shape of the middle flower, then add a circle for its center.

2 Add the Other Flower Shapes
Sketch the other two flower shapes, then add circles starting at the center of the flowers for the form of the petals. These circles are farther apart at the center of each flower and become closer toward the outside.

Develop the Petals

Following the form of the circles, sketch the individual petals, keeping the width uniform.

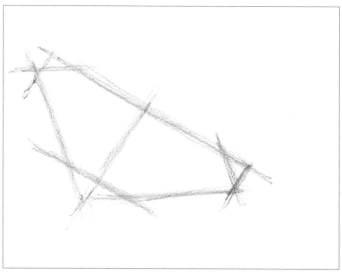

Sketch the Butterfly's Basic Form

On a separate sheet of sketch paper, sketch the basic form of the butterfly, keeping the shape symmetrical, with wings outstretched.

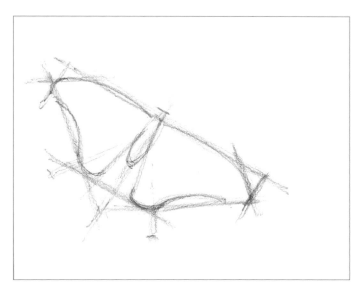

Develop the Form

Develop the form of the butterfly. Add curves to the wings and shape to the body.

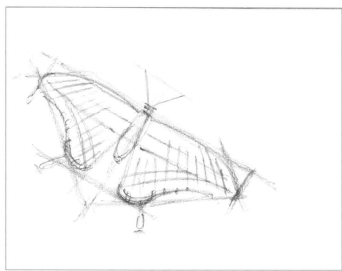

Add Some Details

Include lines for the markings and the antennae.

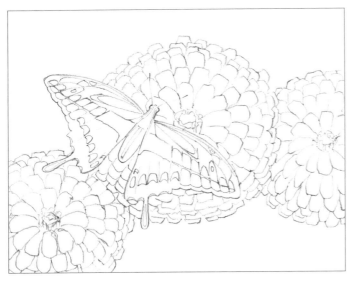

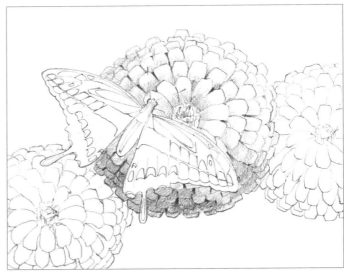

7 Erase or Transfer and Add Details
Erase unwanted lines if working directly on the drawing paper. If you are using sketch paper for the structural sketch, trace or transfer the image onto the drawing paper, omitting unwanted lines and adding details to the wings and flower petals.

8 Add Values to the Middle Flower
With a 2B pencil, add values to the middle flower. Keep in mind that the light source is from the upper right. Make the overall form of the flower lighter at the upper right and darker at the lower left. The curl of the petals is also evident in the shading and is most noticeable at the center of the flower.

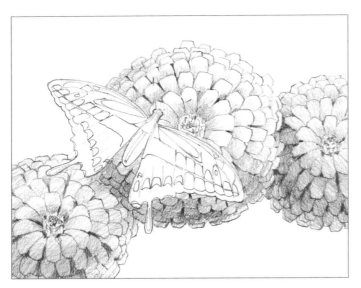

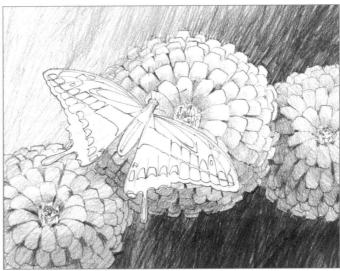

9 Add Values to the Other Flowers
Add values to the other two flowers, shading in a similar manner to the middle flower, only slightly darker.

10 Add Background Values
With a 4B pencil, add the values to the background, keeping it lightest at the upper left.

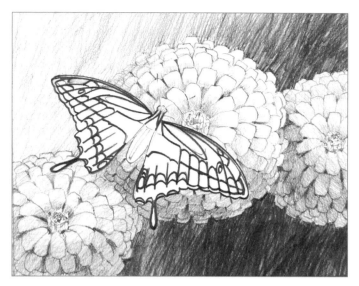

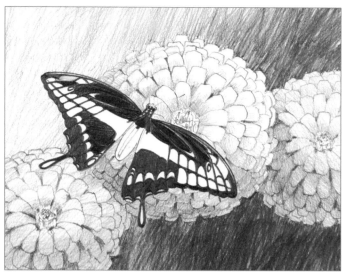

11 Outline the Butterfly
With a 6B pencil, outline the forms and regions of the butterfly. This will make it easier to add the shading.

12 Develop the Butterfly
Add the darkest of the dark values to the butterfly.

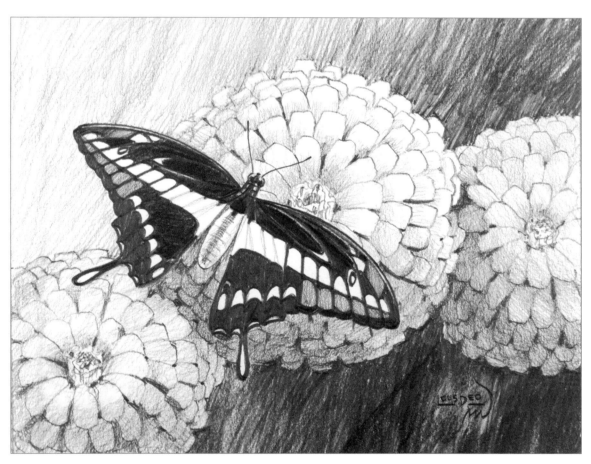

13 Add Values and Make Adjustments
Add any necessary values with the 4B pencil. Adjust by lightening any areas with a kneaded eraser. Add your signature to the front and date the back.

Zinnias and Swallowtail
Graphite pencil on drawing paper
8" × 10" (20cm × 25cm)

Rock Formation

The light is coming from the upper left, casting on the sharp edges of the rocks to create striking and clearly defined shadows. The values of the rock formation groups diminish in contrast as they recede into the background.

1 Proportion the Dominant Rock Formation
With a 2B pencil, sketch the proportions of the most dominant rock formation. Sketch the slope of the foreground hillside.

Materials

Pencils
2B graphite
4B graphite
6B graphite

Paper
10" × 8" (25cm × 20cm) medium-texture drawing paper

Other Supplies
kneaded eraser
value scale

Optional Supplies
10" × 8" (25cm × 20cm) fine or medium-texture sketch paper
lightbox or transfer paper

RELATED TOPICS

• Rocks and Rock Formations
• Clouds and Skies

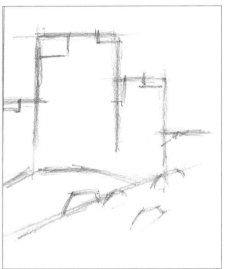

2 Add More Formations
Sketch the basic shape of additional rock formations.

3 Develop the Outer Shapes
Beginning with the most prominent features, develop the outer shapes of the rock formations and the largest of the foreground rocks.

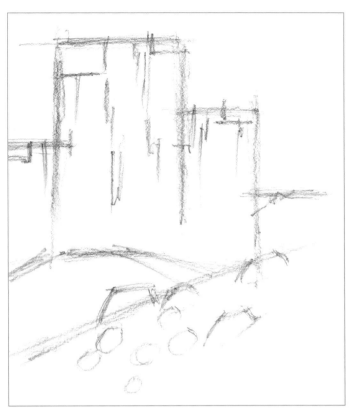

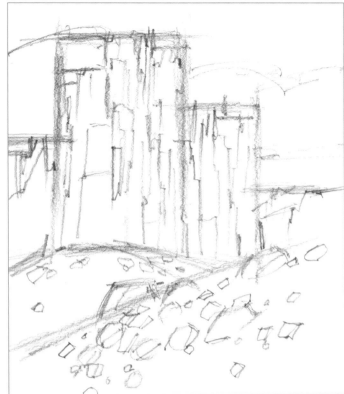

4 **Begin Details and Add Rocks**
Begin sketching the details of the formations and add some of the foreground rocks.

5 **Add More Details**
Add more details to the formations, defining the shapes. Add more foreground rocks and sketch cloud forms.

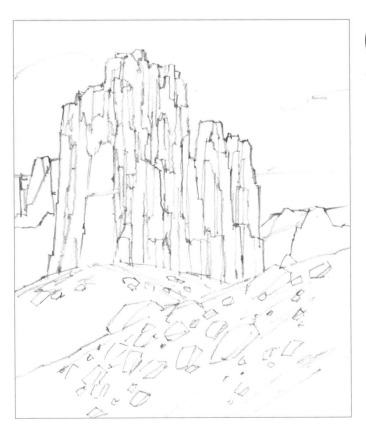

6 **Erase or Transfer and Add Details**
Erase any unwanted lines or transfer the sketch onto drawing paper, omitting any unwanted lines. Add more details as needed.

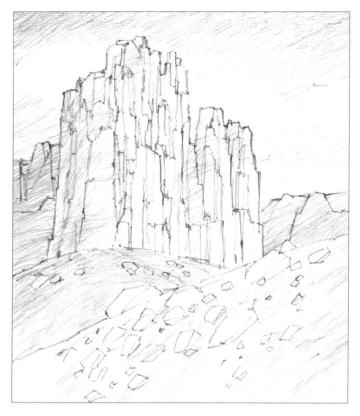

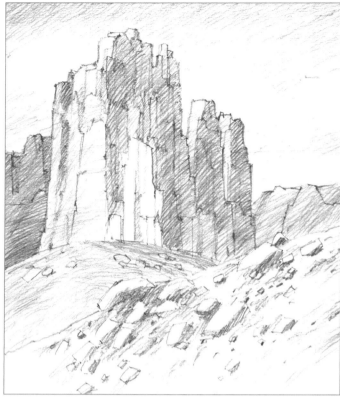

7 Add Lighter Values
With the 2B pencil, add the lighter values, keeping the clouds and much of the foreground white.

8 Add Middle Values
With a 4B pencil, add middle values throughout the drawing.

9 Add Dark Values
With a 6B pencil, add dark values to the shadowed areas.

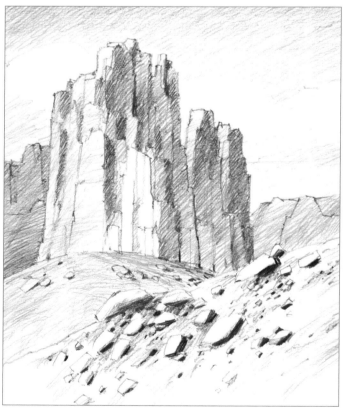

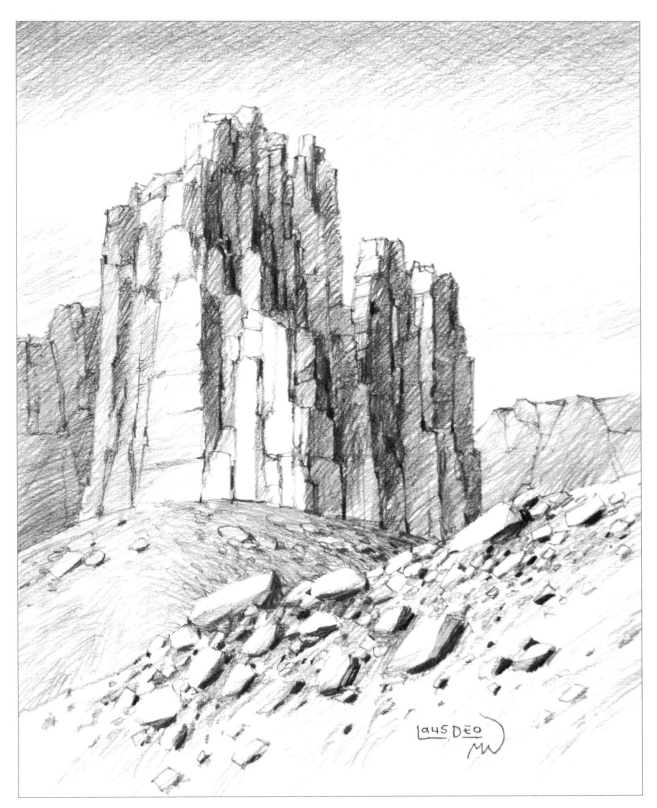

10 **Darken and Lighten to Finish**
Using the 2B, 4B and 6B pencils, add any necessary details such as lines to the rock formations and small foreground rocks. Darken with the pencils or lighten with a kneaded eraser as needed. Add your signature to the front and date on the back.

Rock Formation
Graphite pencil on drawing paper
10" × 8" (25cm × 20cm)

Waterfall

Though the waterfall is the focal point of this drawing, it is the use of graduated and contrasting values that defines the elements and makes the scene interesting. Much of the water and mist is done as negative drawing and kept as the white of the paper.

Materials

Pencils
2B graphite
4B graphite
8B graphite

Paper
9"x6" (23cm × 15cm) medium-texture drawing paper

Other Supplies
kneaded eraser
value scale

Optional Supplies
9"x6" (23cm × 15cm) fine or medium-texture sketch paper
lightbox or transfer paper

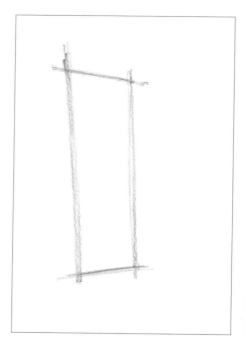

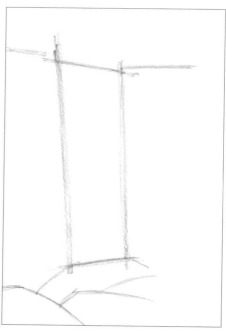

1 Sketch the Basic Shape of the Waterfall
With a 2B pencil, sketch the top, bottom and sides of the waterfall with straight lines.

2 Sketch Boulders and Cliff
Sketch the boulders in the foreground and the cliff tops on the sides of the waterfall.

RELATED TOPICS

- Gauging Values
- Water
- Trees

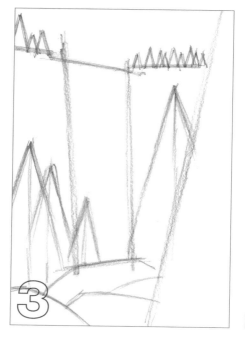

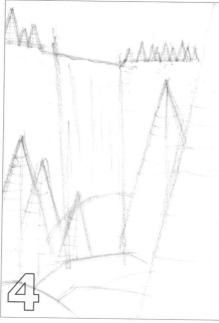

3 Sketch Basic Tree Shapes
Sketch the basic shapes of the evergreens as triangles with a center line for the trunk.

4 Add Details
Add details, including tree branches, rock forms and waterfall lines. Add a curved line for mist at the bottom of the falls.

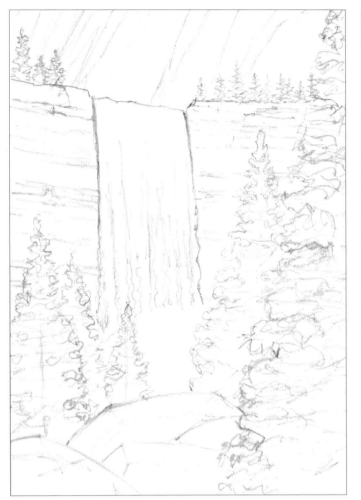

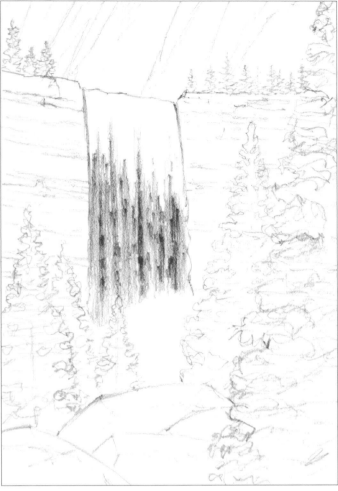

5 Erase or Transfer and Add Details
Erase unwanted lines or transfer the image onto drawing paper, leaving out any unwanted lines.

6 Add Values to the Waterfall
With a 2B pencil, add values to the waterfall, keeping the top and bottom regions white.

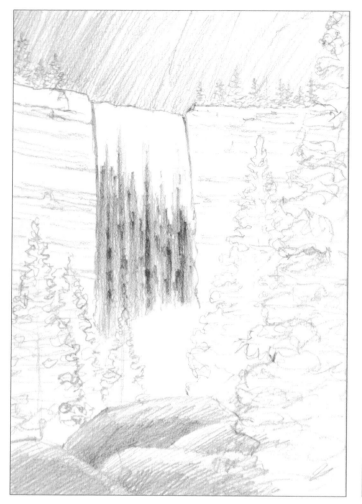

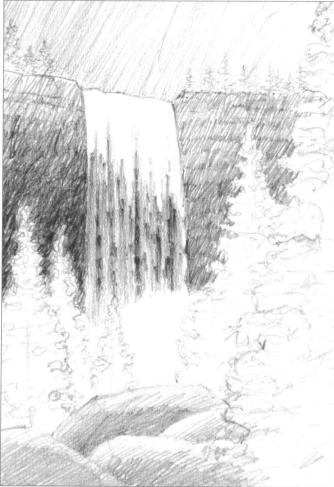

7 **Develop Cliff and Foreground Boulders**
Add values to the cliff face in the distance, above the falls, and to the boulders in the foreground, giving them dimension. Additional darks can be added later.

8 **Develop the Cliff**
With a 4B pencil, add middle values to the cliff face and the sides of the waterfall.

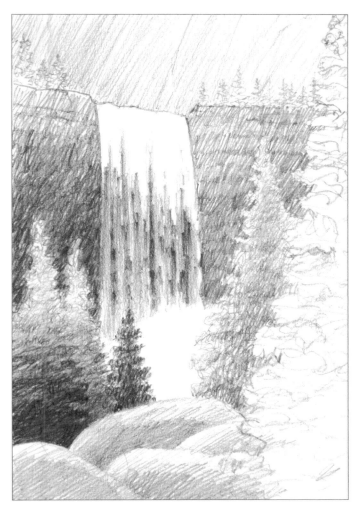

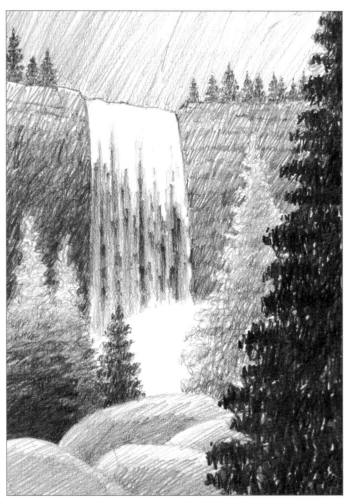

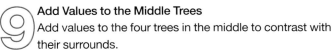

Add Values to the Middle Trees
Add values to the four trees in the middle to contrast with their surrounds.

Add Values to the Background Trees
With the 4B pencil, add middle values to the trees at the top. Add dark values to the tree at the right with an 8B pencil.

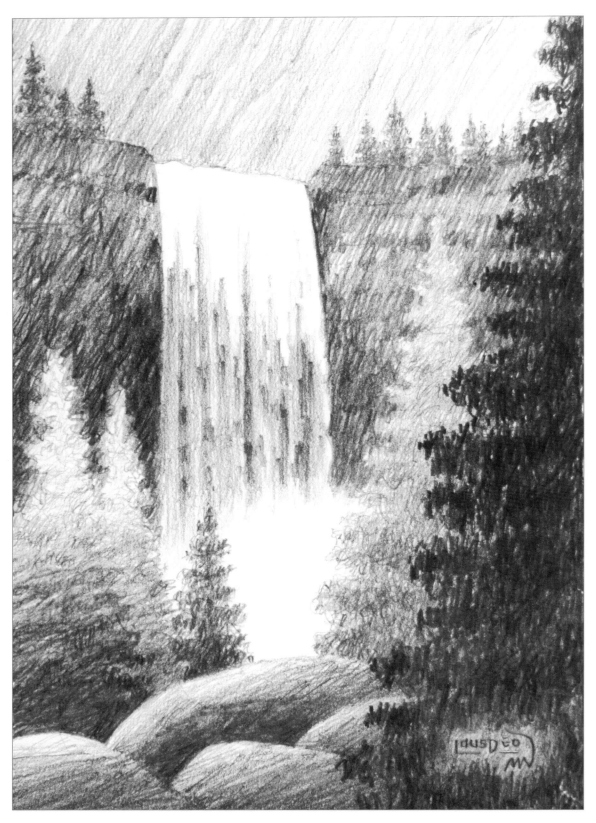

11 Darken and Lighten

With the 2B, 4B and 8B pencils, darken areas such as the boulders and lighten areas, if needed, with a kneaded eraser. Add your signature to the front and the date on the back.

Canyon Waterfall
Graphite pencil on drawing paper
9" × 6" (23cm × 15cm)

Deer in Forest

In this scene, the light source is coming from the upper left. This fact isn't very noticeable except for the shadows cast on the snow and the form shadow of the large tree. The structural sketch of the deer can be done separately from the background and the image enlarged or reduced with a copier, if needed. The structural sketch of the deer can then be combined with the structural sketch of the background for the final drawing process.

Toward the end of the drawing stage, the snow on the background tree limbs can be created by lifting out the graphite with a kneaded eraser.

Materials

Pencils
2B graphite
4B graphite
6B graphite

Paper
8" × 10" (20cm × 25cm) medium-texture drawing paper

Other Supplies
kneaded eraser
value scale

Optional Supplies
8" × 10" (20cm × 25cm) fine or medium-texture sketch paper
lightbox or transfer paper

RELATED TOPICS

- Light and Shadow
- Linear Perspective
- Atmospheric Perspective
- Ice and Snow
- Trees
- Deer

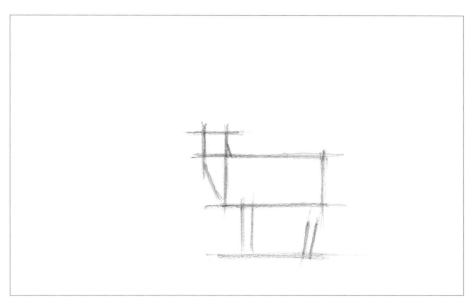

1 Sketch the Deer's Basic Shape
With a 2B pencil, sketch a rectangle for the body and a horizontal line as a baseline for the hooves. Add a square for the head and lines for the neck and legs.

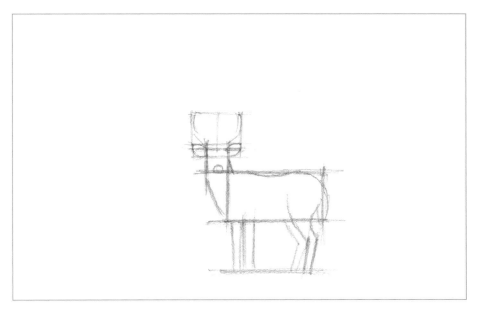

2 Add to the Deer's Basic Shape
Add ears, nose and legs to the basic shape. Start to sketch the antlers and develop the outer form, including the tail.

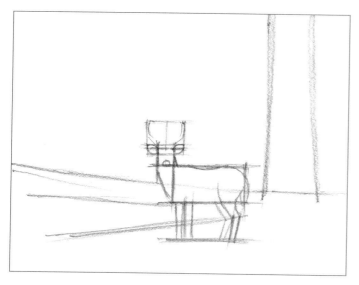

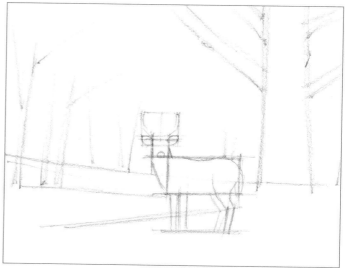

3 **Sketch the Large Tree and Snow**
Sketch two vertical lines as the basic shape of a large tree on the right. For snow forms, make horizontal lines at the lower portion of the picture.

4 **Develop Tree Forms**
Add basic tree forms in the background and develop the form of the large tree.

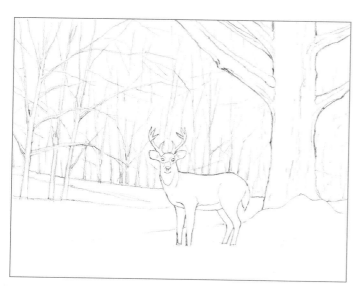

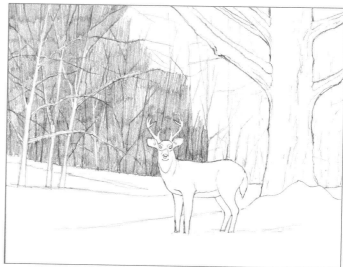

5 **Erase or Transfer and Add Details**
Erase unwanted lines or transfer the image onto drawing paper, leaving out any unwanted lines. Add detail lines to the trees and deer, including snow on the tree limbs.

6 **Add Values to the Background**
With the 2B pencil, add the values to the background trees. Avoid shading the snow on the larger tree limbs.

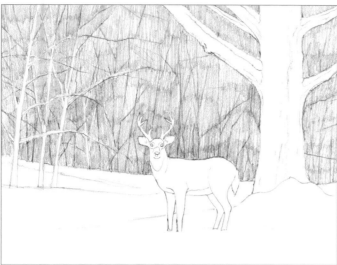

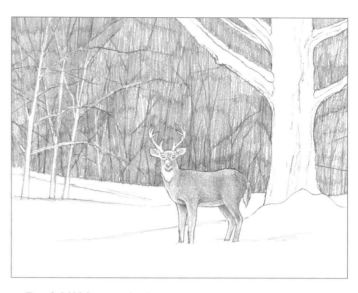

7 Continue Developing the Background
Continue adding values to fill in the background trees.

8 Add Values to the Deer
Add values to the head and body of the deer. The antlers are to be kept white, so as to contrast with the background.

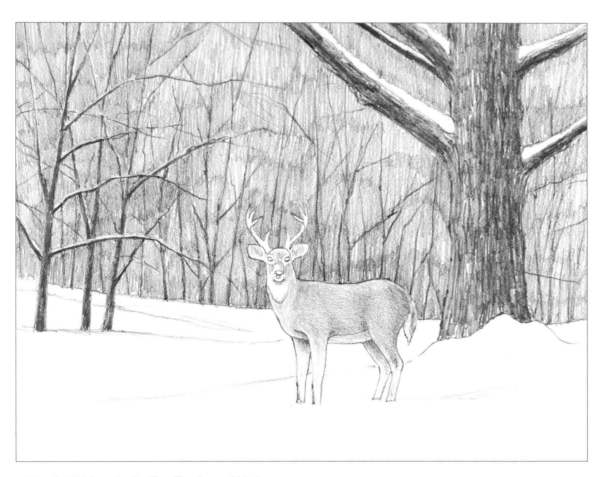

9 Add Values to the Tree Trunks and Limbs
With a 4B pencil, add the values to the trunks and limbs of the trees, making sure they are slightly darker than the background.

10 Darken the Background Trees

With a 6B pencil, shade the background trees to the middle and right. This will give contrast to the deer and better define its form.

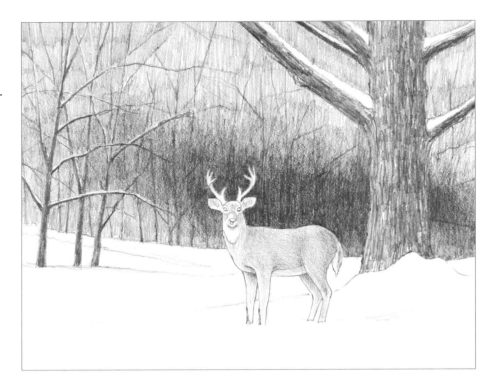

11 Darken the Shadows on the Snow

With the 4B pencil, darken the cast and form shadows on the snow.

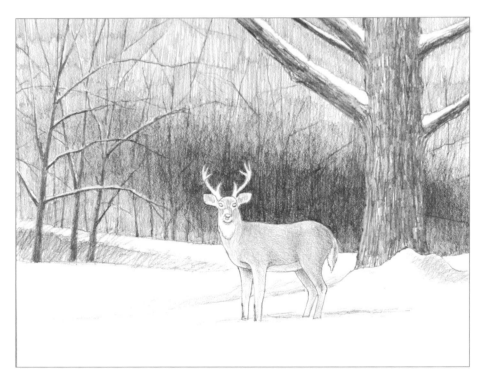

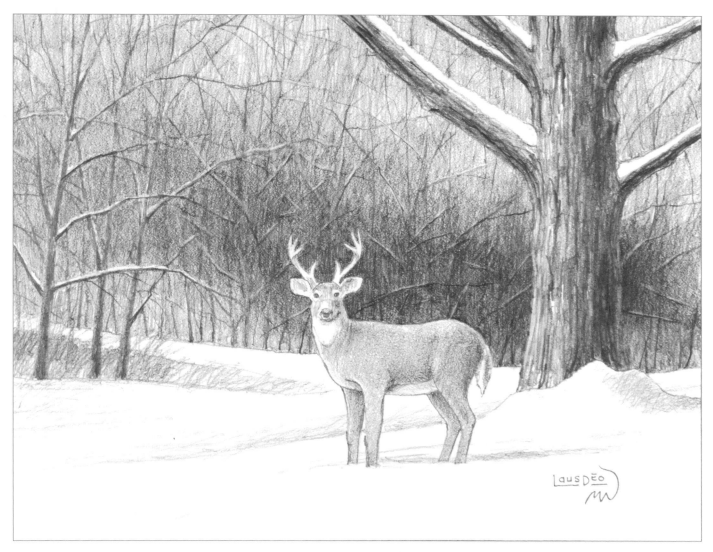

12 Add Details and Make Adjustments

Add details and shading to the deer, tree trunk and limbs. Make adjustments, including darkening the background tree branches and lifting graphite with a kneaded eraser to show snow on those branches. Add your signature to the front and the date on the back.

Deer in Forest
Graphite pencil on drawing paper
8" × 10" (20cm × 25cm)

Beach Scene

Several vacation photos were combined to create this scene which includes sky, clouds, water, waves and palm trees. The light source is from the upper right causing the clouds to be lighter at the upper right portions of their round forms. The sky behind the clouds is dark at the top, graduating to light at the bottom.

Materials

Pencils
2B graphite
6B graphite

Paper
9" × 6" (23cm × 15cm) medium-texture drawing paper

Other Supplies
kneaded eraser
value scale

Optional Supplies
9" × 6" (23cm × 15cm) fine or medium-texture sketch paper
lightbox or transfer paper

RELATED TOPICS

• Water
• Clouds and Skies
• Trees

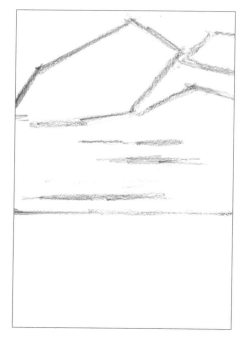

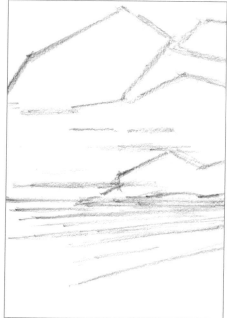

1 Sketch the Horizon and the Basic Cloud Shapes
Sketch a line for the horizon. Sketch the large, basic shapes of the clouds as simple lines.

2 Sketch the Basic Shapes of the Trees and Waves
Sketch a line slightly below the horizon as the land that the trees are on. Sketch the basic shapes of the land, rocks and trees. Sketch lines for the waves, making sure that the angles increase as you work farther down the scene to demonstrate perspective.

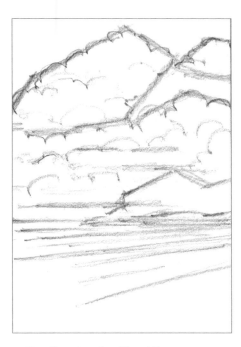

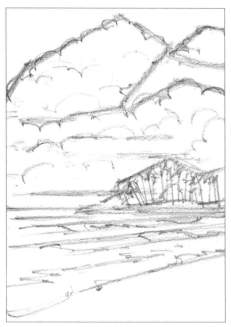

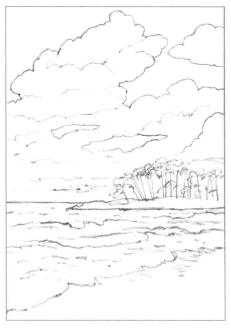

3 Develop the Cloud Forms
Following the previously drawn shapes, develop the forms of the clouds, which may be round and fluffy toward the top and flatter at the bottom.

4 Develop the Trees and Waves
Develop the tree trunks and the forms of the leaves and branches. Sketch the areas of the white caps and foam of the waves.

5 Erase or Transfer and Add Details
Erase unwanted lines or transfer the image onto drawing paper, absent of unwanted lines.

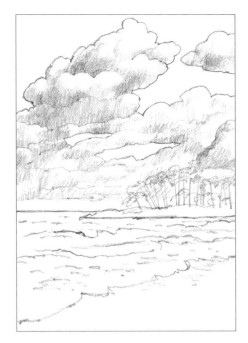

6 Add Values to the Clouds
With a 2B pencil, start adding values to the clouds. Keep the lighter areas as the white of the paper.

7 Add Values to the Sky
Darken the sky around the clouds, which is very dark at the top and lightens as it goes toward the horizon.

8 Add Values to the Water and Beach
Keep the whitecaps and foam pure, using the white of the paper. Add values to the water and beach. Near the horizon, the water should be darker than the sky.

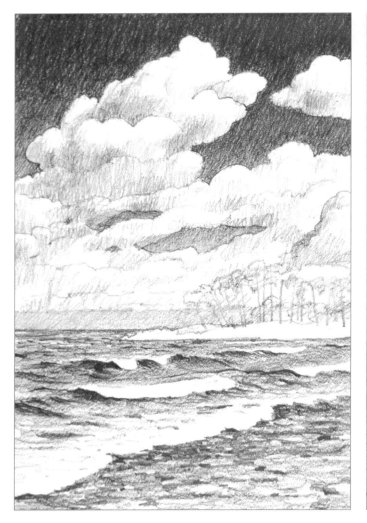

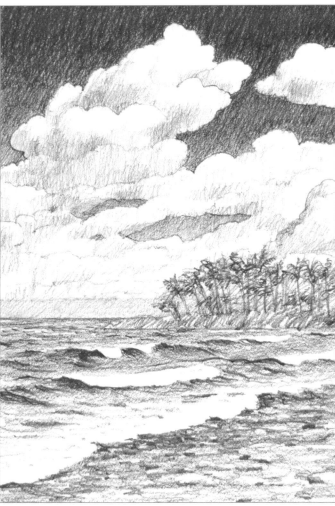

9 **Add Darks**
With a 6B pencil, add darks to the top of the waves. This is most noticeable underneath the curl of some of the whitecaps. Add darks to show off scattered rocks and wet beach.

10 **Add Values to the Land and Trees**
With the 2B pencil, add the light and middle values to the land and palm trees.

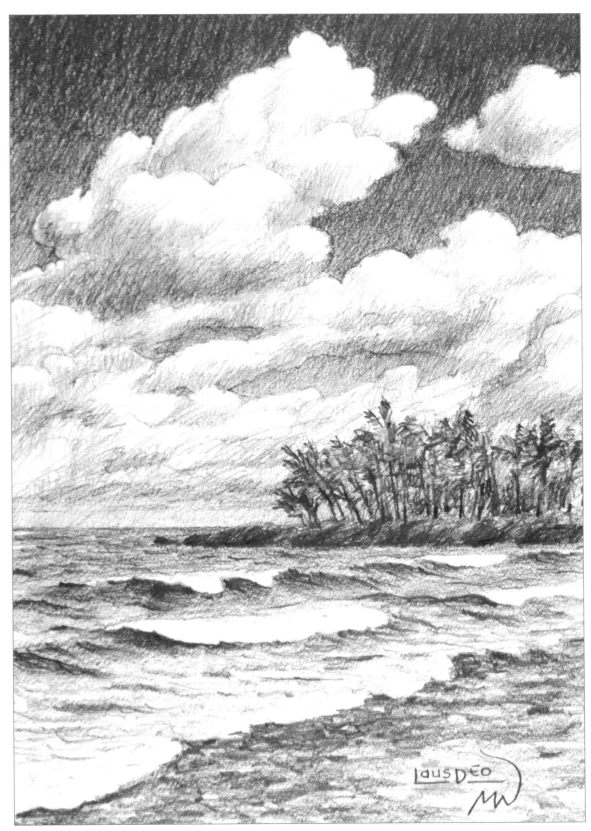

11 Finish the Drawing
Make adjustments by darkening with a 6B pencil and lightening with a kneaded eraser. Add your signature to the front and the date on the back.

Holiday Beach
Graphite pencil on paper
9" x 6" (23cm × 15cm)

Great Blue Heron

The contrasts of this scene are strategically placed to bring emphasis to the head of the bird and form to the body as well as to create a pleasing composition. Though the main subject of this drawing is the bird, the environment that it is in is also important. Just as details are added to the heron, such attention can be paid to the grass, ground and water.

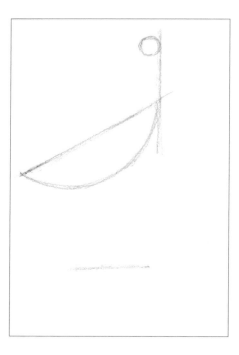

1 Sketch the Basic Shape of the Bird
With a 2B pencil, sketch a diagonal line for the top of the body of the heron, then a curved line for its underside. Sketch a vertical line to help with the placement of the head, which is shown as a small circle. Add a horizontal line below the body for the placement of the feet.

Materials

Pencils
2B graphite
6B graphite

Paper
9" × 6" (23cm × 15cm) medium texture drawing paper

Other Supplies
kneaded eraser
value scale

Optional Supplies
9" x 6" (23cm × 15cm) fine or medium-texture sketch paper
lightbox or transfer paper

RELATED TOPICS

• Water
• Birds

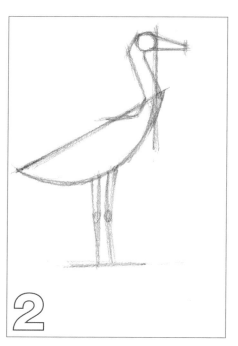

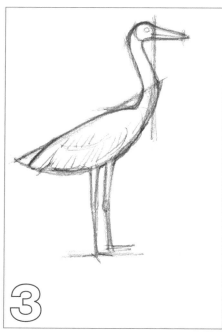

2 Develop the Heron's Basic Shape
Add the beak, neck and legs to the bird's basic shape.

3 Develop the Form
Round the lines, add the feet and some of the feathers to develop the bird.

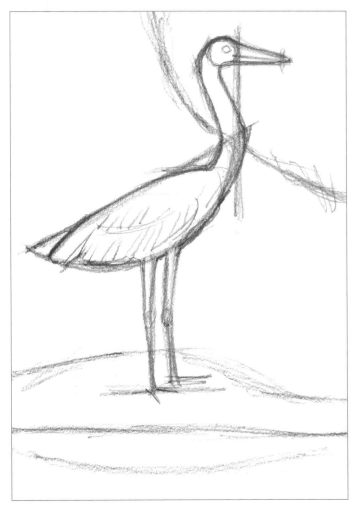

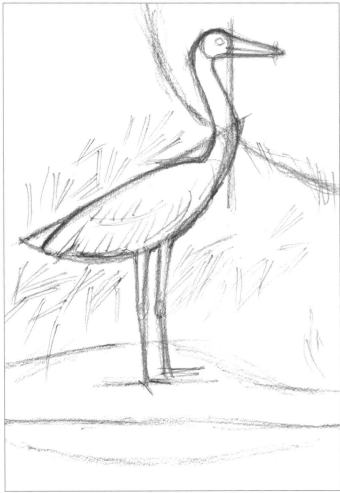

4 Sketch the Basic Shapes Around the Heron

Sketch the basic lines and shapes of the area surrounding the heron to place the grass, bank, water and reflection.

5 Sketch the Grass

Start sketching the blades of grass in the background. Each blade is two parallel lines.

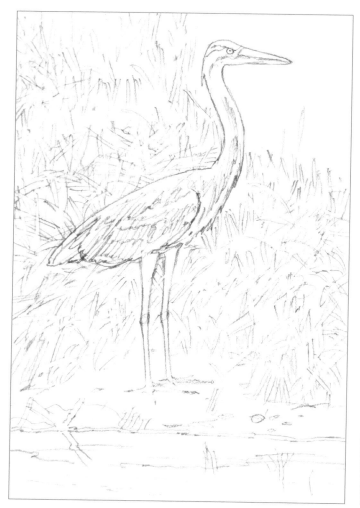

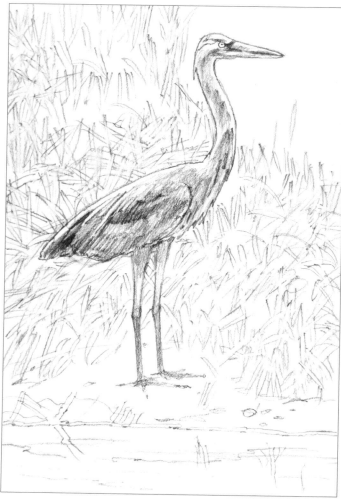

6 Erase or Transfer and Add Details
Erase unwanted lines or transfer the image onto the drawing paper, absent of unwanted lines. Add details to the feathers and erase any unwanted lines where the grass blades overlap each other.

7 Add Value to the Bird
With the 2B pencil, start adding values to the heron. The head and neck should remain mostly light so it will contrast against the background, which will be drawn dark.

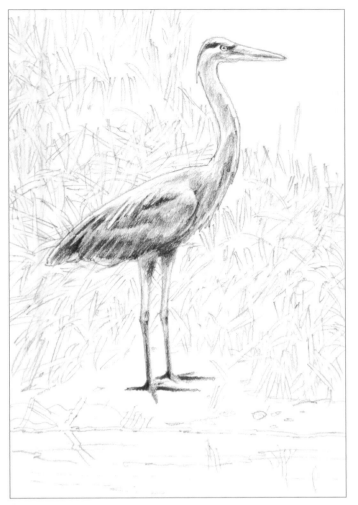

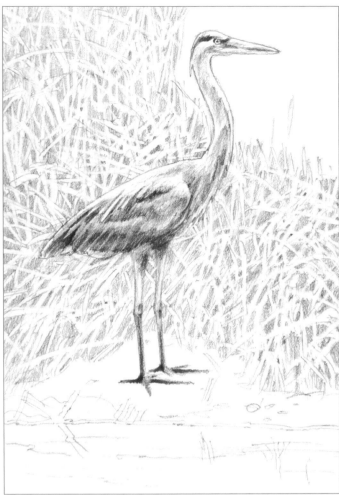

Continue Developing the Bird
Add more values, lights and darks, to the heron, giving depth and definition.

Add Values to the Background
Start filling in the values around the grass, leaving the blades white. More grass blades may be added by erasing some of the graphite with a kneaded eraser.

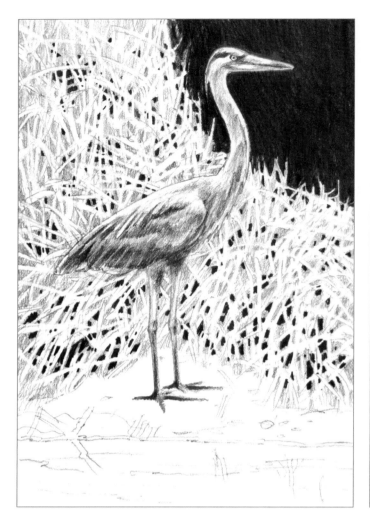

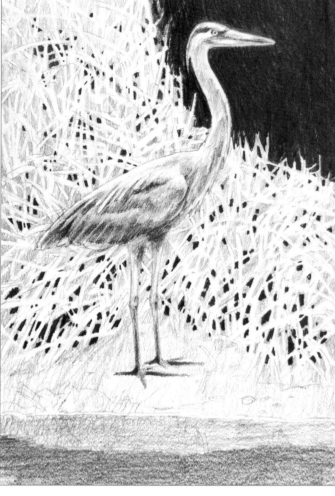

10 Add Darks to the Background
With a 6B pencil, add darks to the background including some of the areas between the blades of the grass.

11 Add Values to the Foreground and Water
With the 2B pencil, add values to the foreground and water, keeping a strip of white at the water line.

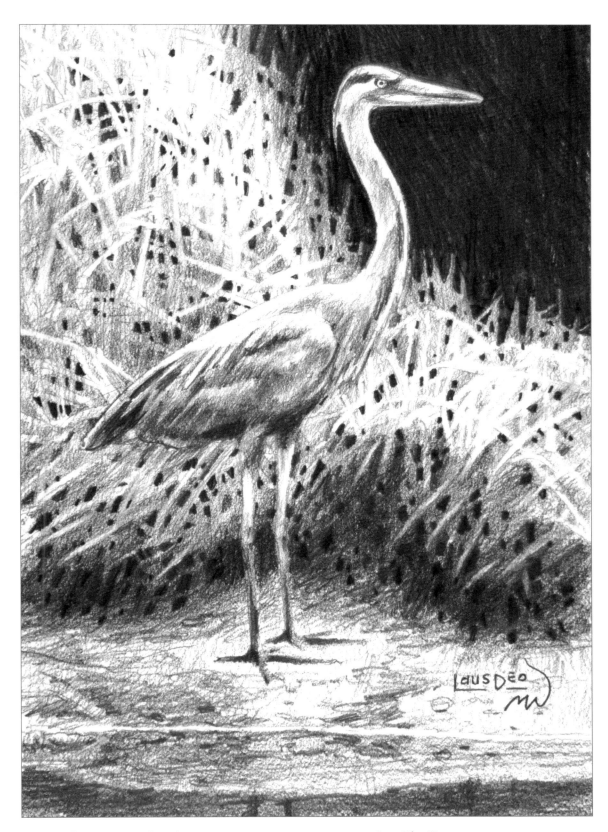

12 **Finish the Drawing**
Add details throughout and make adjustments, including additional values to the grass and water, and lightening some of the blades of grass. Add your signature to the front and the date on the back.

Great Blue Heron
Graphite pencil on drawing paper
9" × 6" (23cm × 15cm)

Chipmunk on a Tree Stump

For this drawing, the structure of the chipmunk is worked out before the tree stump because it is easier to adjust the tree stump to the chipmunk than the chipmunk to the tree stump. The light source is coming from the upper left and affects the lights and shadows of the chipmunk and tree stump. The background varies in values to contrast with the elements in front.

RELATED TOPICS

• Trees
• Small Animals

1 Sketch the Chipmunk's Basic Proportions
With a 2B pencil, sketch a diagonal line for the underside of the chipmunk. Add lines to place proportions for the length and width of the body.

2 Develop the Body Shapes
Following the proportions, sketch the basic shapes of the body, head and tail. Add a baseline for the feet, then the basic shapes of the legs.

3 Develop the Form
Develop the form, following the basic shapes, including adding the eye and ears.

4 Add Details

Start to add details, including stripes in the fur, and defining features such as its paws.

5 Sketch the Basic Form of the Tree Stump

With simple linework, sketch the form of the tree stump.

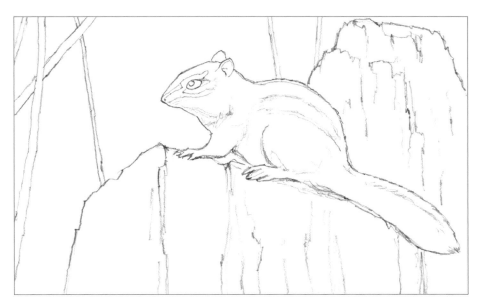

6 Erase or Transfer and Add Details

Erase any unwanted lines or transfer the structural sketch onto the drawing paper, leaving out unwanted lines. Add structural details to the chipmunk, tree stump and background.

7 Add Light and Middle Values to the Chipmunk

With the 2B pencil, add light and middle values to the chipmunk. The short pencil strokes can follow the direction of the fur.

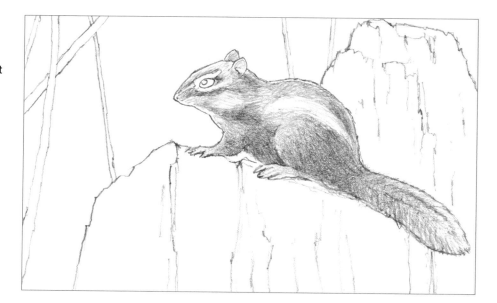

8 Add Darker Values

Continue working on the chipmunk, adding darker values which will add depth to the form and distinction to the features.

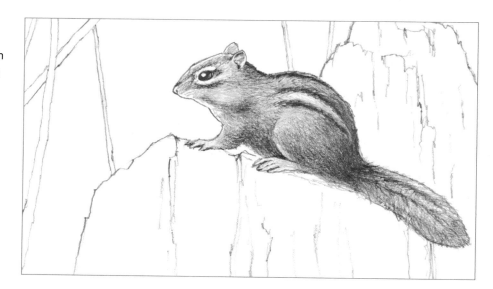

9 Add Values to the Tree Stump

Start adding the range of values of the tree stump with vertical pencil strokes that display its texture.

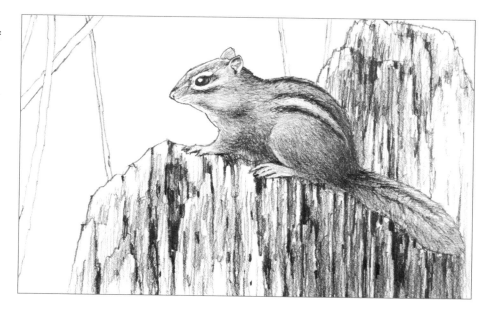

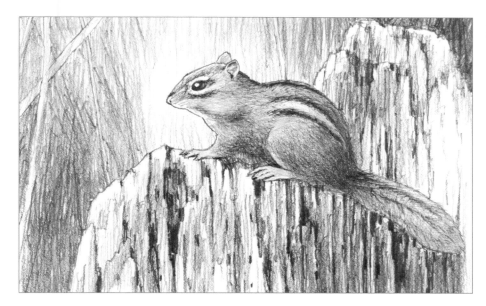

10 Continue Developing the Background
Add a range of values behind the chipmunk and tree stump.

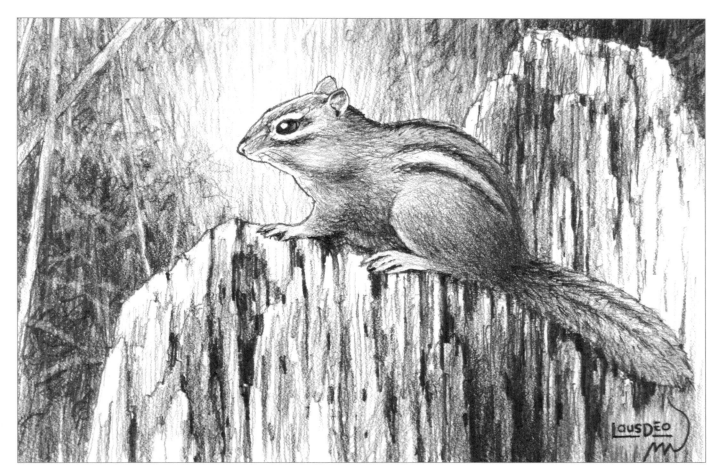

11 Finish the Drawing
Add details throughout, making some areas darker with a 4B pencil. Make adjustments such as lifting graphite from the background with a kneaded eraser. Add your signature to the front of the drawing and the date on the back.

Chipmunk on a Tree Stump
Graphite pencil on drawing paper
6" × 9" (15cm × 23cm)

Mountain Majesty

The individual subjects in this demonstration rely mostly on their outer forms for recognition. The closest trees are large and dark, and those farther away will be more neutral, making use of linear and atmospheric perspective. Refer back to earlier demonstrations for step-by-step instructions on individual subjects.

Materials

Pencils
2B graphite
4B graphite
6B graphite

Paper
12" x 9" (30cm × 23cm) medium-texture drawing paper

Other Supplies
kneaded eraser
value scale

Optional Supplies
12" x 9" (30 cm × 23cm) fine or medium-texture sketch paper
lightbox or transfer paper

1 Sketch the Basic Shape of the Mountains
Use a 2B pencil to sketch the basic form of the mountains, with the peak on the left slightly taller than the one on the right.

2 Sketch the Larger Tree Shapes
Make triangles for the basic shapes of the larger trees with a center line for the trunk.

RELATED TOPICS

- Linear Perspective
- Atmospheric Perspective
- Mountains
- Trees
- Eagle in Flight

3 Draw the Small Tree Shapes
Sketch the shapes of the smaller and more distant trees. These trees don't need center trunk lines.

4 Add Basic Shape of the Eagle's Wings
Sketch four lines as the basic shape of the eagle's wings, paying attention to the curve and direction of the lines. Add more lines for the body and tail feathers.

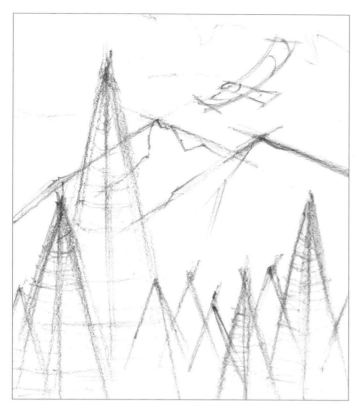

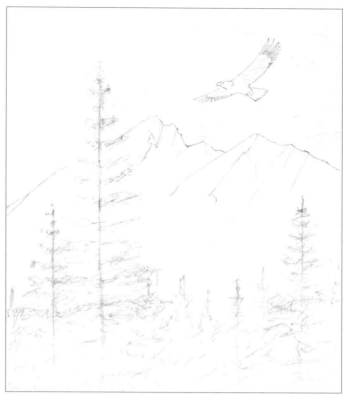

5 **Define the Basic Shapes**
Add linework to the trees, mountains and eagle to define their forms. Lines are added for the clouds.

6 **Erase or Transfer and Add Details**
Erase any unwanted lines or transfer the sketch onto the drawing paper, omitting any unwanted lines. Add detail linework to the trees, mountains and eagle.

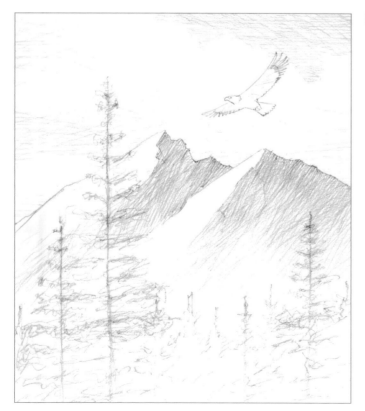

7 **Add Lighter Values to the Background**
With the 2B pencil, add lighter values to the sky and mountains. The mountains remain white on their left sides.

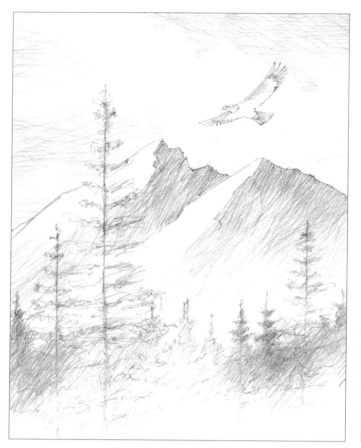

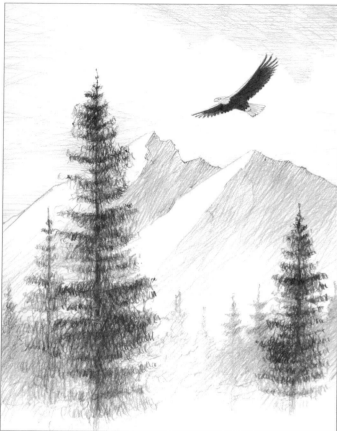

8. Add Values to the Distant Trees and Eagle

Add values to the eagle with the 2B pencil. With a 4B pencil, add middle values to the distant trees, making them darker at the top.

9. Darken the Eagle and Foreground Trees

With a 6B pencil, add dark values to the eagle and the foreground trees.

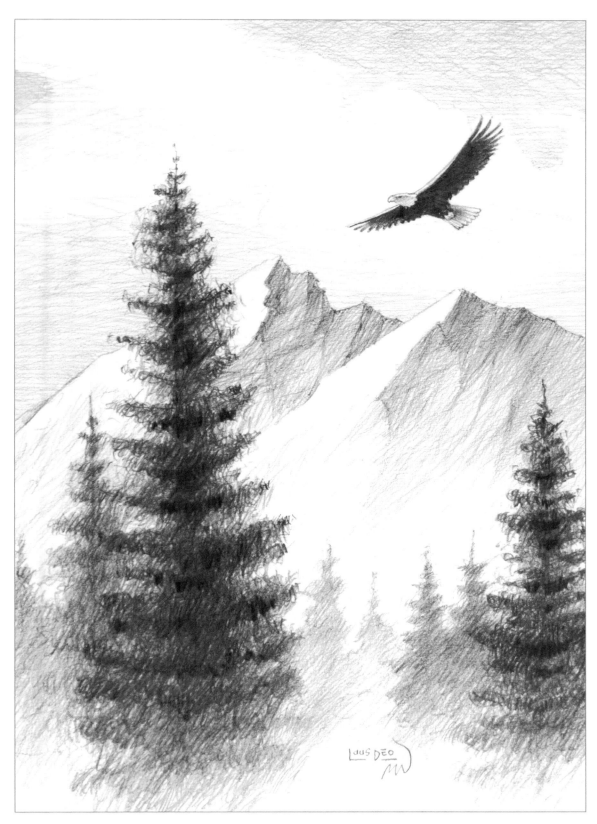

10 Finish the Drawing

Darken areas as needed with the 4B and 6B pencils and lighten other areas with a kneaded eraser to complete the drawing. Add your signature to the front and date the back.

Mountain Majesty
Graphite pencil on drawing paper
12" × 9" (30cm × 23cm)

Canada Geese in Winter Snow

With their bold contrasts of lights and darks, Canada geese make a good subject matter for drawing. In this picture, their webbed feet are lost in the snow making the drawing process a little easier. The winter sky is darker at the top and gradually gets lighter as it goes downward. The tall grasses are drawn over the sky. The structural sketches of the geese can be done separately and then combined for the final drawing.

1 Sketch the Basic Shape of the First Goose
With a 2B pencil, sketch two horizontal lines, a vertical line on the right and a diagonal line on the left for the proportions of the body. Add a circle for the head and a horizontal line below the body for the feet, which will be hidden by the snow.

Materials

Pencils
2B graphite
4B graphite
6B graphite

Paper
10" × 8" (25cm × 20cm) medium-texture drawing paper

Other Supplies
kneaded eraser
value scale

Optional Supplies
10" × 8" (25cm × 20cm) fine or medium-texture sketch paper
lightbox or transfer paper

RELATED TOPICS

- Ice and Snow
- Goose

2 Develop the Form
Develop the overall form of the goose by sketching an oval for the body and adding straight lines for the neck, beak and legs.

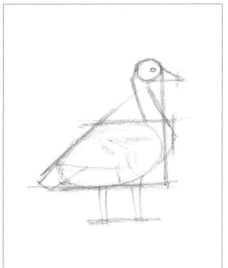

3 Add Details
Start to add details with the 2B pencil, adding form to the neck and placing the feathers and the eye.

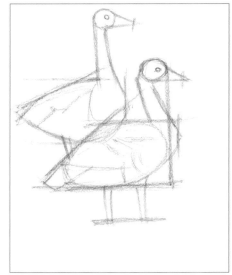

4 Sketch the Background Goose
Following the steps used to sketch the foreground goose, sketch the goose in the background.

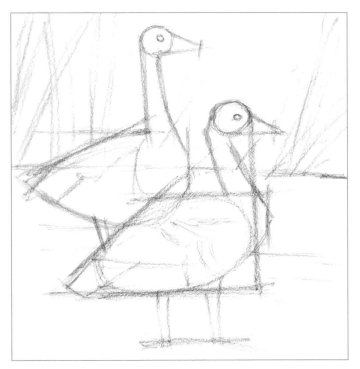

5 **Add Background and Foreground Lines**
Add lines for the background including the grass. Some lines can be added to the foreground for the contours of the snow.

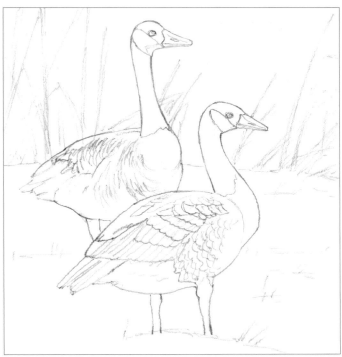

6 **Erase or Transfer and Add Detail Lines**
Erase any unwanted lines or transfer the sketch onto drawing paper, leaving out unwanted lines. Add detail lines such as the feathers.

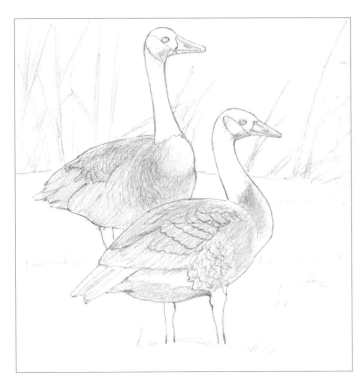

7 **Add Light Values to the Geese**
With the 2B pencil, add the lighter values to the geese.

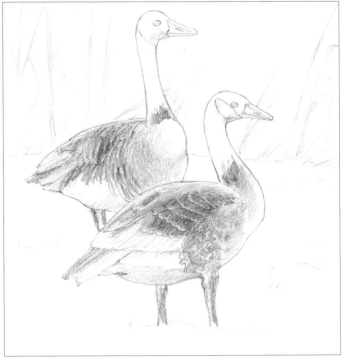

8 **Add Middle Values to the Geese**
With a 4B pencil, add the middle values to the geese. Many of the feathers are lighter at the ends.

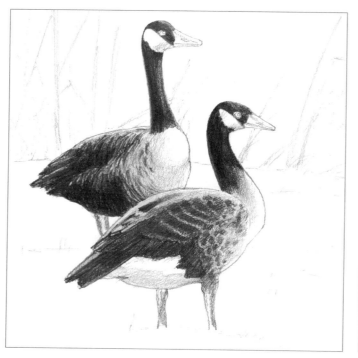

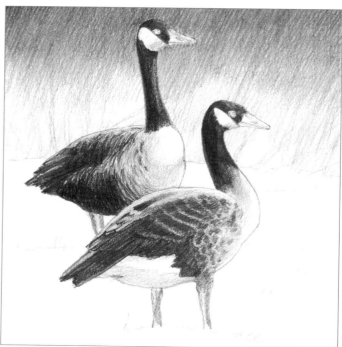

9 **Add Dark Values to the Geese**
With a 6B pencil, add the darker values to the geese.

10 **Add Values to the Sky**
With the 4B pencil, add values to the sky so that it appears darker at the top.

11 **Add Grass**
Add the grass in the background, first by erasing some of the grass that has been darkened by shading in the sky, then by drawing in some of the grass.

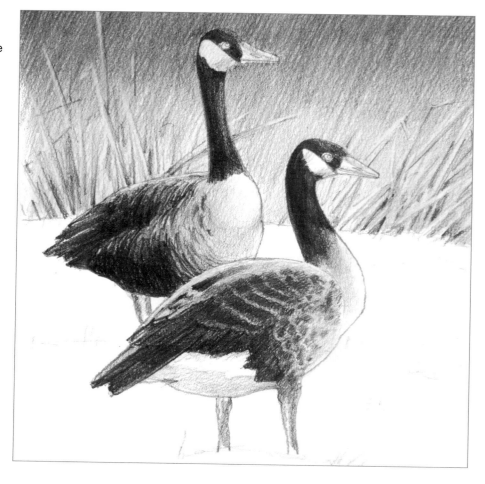

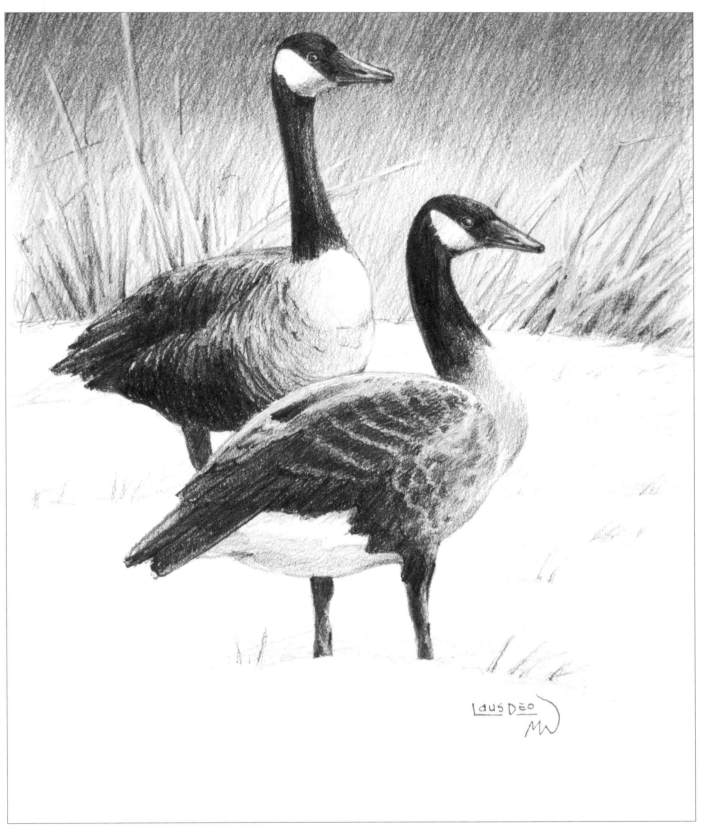

12 **Finish the Drawing**
Add details to the geese and values to the foreground grass and snow. Make any necessary adjustments. Sign the front and date the back.

Winter Geese
Graphite pencil on drawing paper
10" x 8" (25cm × 20cm)

Proper presentation will make your artwork look even better and also preserve and protect it from aging for years to come.

Spraying With Fixative

Fixative may be sprayed over the surface of the artwork to prevent smearing, which is more of a concern with charcoal or pastel drawings than with graphite. Make sure the artwork is free of dust and follow the instructions on the can for applying the spray. Make sure you do it in a well-ventilated area.

Finishing Your Artwork

The right frame and mat will enhance your drawing and give it a professional look, with glass in the front and a sheet of craft paper to cover the back, the artwork will be more protected.

Finishing Touches
Now your artwork is ready to be displayed. Hang your artwork with an attractive mat and frame.

Conclusion

Once you have studied a composition with a drawing, you may now want to take it further by doing the composition with another medium, such as watercolors or oils. Our other *Absolute Beginner* books are great resources for learning a new medium and working with different subjects as you continue on your artistic journey.

Have fun and keep up the good work!

~Mark and Mary Willenbrink

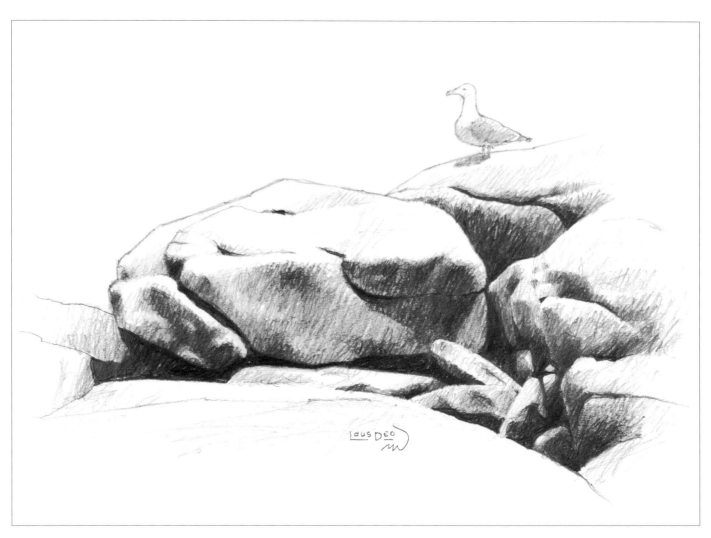

Shore Rocks and Gull
Graphite pencil on drawing paper
8½" × 11" (22cm × 28cm)

Glossary

A

Angle ruler: a small ruler that can fold in the middle and is used for measuring and transposing angles.

Art principles: visual concepts inherent to art, including perspective, values, light and shadow and composition.

Asymmetrical composition: a composition that has a balanced feel without having the elements even from side to side.

Atmospheric perspective: also referred to as aerial perspective, this is depth expressed through values and the amount of definition.

B

Blending stump: also referred to a tortillion, this is a small roll of soft, tightly wound paper that is used for blending on the paper surface.

Blocking-in: the process of making a structural sketch of the basic overall shape and proportions of a subject.

C

Carbon pencil: a pencil with a carbon core.

Cast shadow: a shadow that is cast from an object onto another surface.

Charcoal pencil: a pencil with a charcoal core.

Colored pencil: a pencil with a colored core. These pencils are also available in black, white and grays.

Composition: the arrangement of elements of a scene.

Contrast: differing values.

Craft knife: a small knife with a sharp, replaceable blade.

Cropping: to determine the perimeters of a scene or piece of artwork.

Crosshatching: groups of parallel pencil lines that overlap in different directions.

D

Design elements: elements that are found in composition, including size, shape, line and values.

Design principles: the use of design elements, including balance, unity, dominance and rhythm.

Dividers: a compass-like tool used for measuring and proportioning.

Drawing: a finished piece of art.

Drawing board: a smooth, sturdy board used as a support for sketch or drawing paper.

Drawing paper: heavy-weight paper used for drawing.

E

Ellipse: the shape of a circle when it is viewed from the side, as in perspective.

Eraser shield: a thin piece of metal used to mask areas of a drawing during erasing.

F

Form shadow: a shadow that appears on an object, displaying its form.

Frisket: a sheet of paper used to cover part of a drawing to control the placement of the pencil lines.

G

Gauging values: comparing the values of the lights and darks of a drawing with its subject.

Golden ratio: also referred to as the golden mean, golden section or Fibonacci number, a mathematical equation found in nature that can be applied to a composition.

Graduating lines: pencil lines that graduate light to dark or dark to light.

Graphite pencil: a pencil with a graphite core.

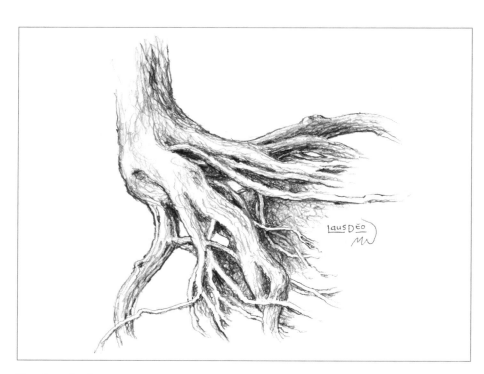

Tree Root Study
Graphite pencil on drawing paper
8½" × 5" (22cm × 13cm)

H

Highlight: where light reflects off of an object and causes a bright spot.

Horizon: the line where the sky meets the land or water.

Horizontal line: a line that goes across the page.

I

Identifiable form: the form of a subject that is identifiable.

K

Kneaded eraser: a gray putty-like eraser.

L

Lead holder: a type of mechanical pencil that uses thicker graphite lead than other mechanical pencils.

Lightbox: a shallow box with an interior light that shines through a translucent outer surface that is used for tracing.

Light source: the origin of light of a scene or subject.

Line comparisons: comparing the placement of the elements of a subject with lines.

Linear perspective: depth expressed through the size and placement of elements of a scene.

M

Masking tape: paper tape used to attach one piece of paper to another.

Mechanical pencil: a pencil that uses refillable graphite lead.

N

Negative drawing: darkening around a subject so that the image is defined by the background.

P

Parallel lines: pencil lines that follow the same direction.

Pastel pencil: a pencil with a pastel chalk core.

Pencil extender: a pencil handle with a sleeve used to hold shortened pencils.

Pencil sharpener: a device used to sharpen pencils.

Plastic eraser: a soft nonabrasive eraser, usually either white or black.

Positive drawing: drawing a subject on a background rather than around the subject, like negative drawing.

Proportioning: comparing the dimensions of a subject.

Proportioning devises: tools that are used for proportioning such as dividers or a sewing gauge.

R

Reference material: photos, sketches or drawings used to study a subject.

Reflected light: light that is reflected from one surfaced onto another.

Rule of Thirds: a composition that has the elements placed along a grid that is divided into thirds.

S

Sandpaper pad: a small pad of sandpaper that is used to sharpen the core of a pencil.

Scribbling: random, multi-directional pencil lines.

Sewing gauge: a tool with a movable guide that is used for measuring and proportioning.

Shading: the lights and darks of a subject displayed through the pencil lines of a sketch or drawing.

Sketch: a rough, unfinished art representation.

Sketch paper: lightweight paper used for sketching.

Spray fixative: a spray coating applied to artwork to prevent smearing.

Structural sketch: a sketch of the structural form of a subject, absent of values.

Surface texture: the coarseness of the surface of the paper.

Symmetrical composition: a composition that has evenly balanced elements from side to side.

T

Tangent: the place where two or more elements meet or overlap.

Thumbnail sketch: small quick sketches used for working out ideas and planning compositions.

Tooth: a term for the surface texture of the paper.

Tracing paper: thin, translucent paper used for tracing.

Transfer paper: also referred to a graphite paper, a paper covered with graphite, used for transferring a sketch onto a sheet of drawing paper.

Transposing angles: copying the angles of the subject when sketching or drawing.

V

Values: the lights and darks of a subject.

Value scale: (also referred to as a gray scale or value finder): a small piece of cardboard that has a range of lights and darks and is used for gauging values.

Vanishing point: a point at which parallel lines visually converge in the distance.

Vertical line: a line that goes up and down the page.

Viewfinder: a small piece of plastic or cardstock used as a hand-held window to visually crop a scene.

W

Woodless pencil: a pencil made of a cylinder of graphite; the lead is coated with lacquer but it has no outer wood casing.

Index

About the Authors

Mark and Mary Willenbrink are the bestselling authors of the *Absolute Beginner* series. Mark is also a fine artist and teaches art classes and workshops. His website is shadowblaze.com and you can also find his fanpage on Facebook. Mark and Mary live in Cincinnati, Ohio with their three children, two cats and rescued border collie.

Photo by Hannah Willenbrink

Drawing Nature for the Absolute Beginner. Copyright © 2013 by Mark and Mary Willenbrink. Manufactured in USA. All rights reserved. No part of this book may be reproduced in any form or by any electronic or mechanical means including information storage and retrieval systems without permission in writing from the publisher, except by a reviewer who may quote brief passages in a review. Published by North Light Books, an imprint of F+W Media, Inc., 10151 Carver Road, Suite 200, Blue Ash, OH 45242. (800) 289-0963. First Edition.

Other fine North Light Books are available from your favorite bookstore, art supply store or online supplier. Visit our website at fwmedia.com.

17 16 15 5 4

ISBN: 978-1-4403-2335-5

DISTRIBUTED IN CANADA BY FRASER DIRECT
100 Armstrong Avenue
Georgetown, ON, Canada L7G 5S4
Tel: (905) 877-4411

DISTRIBUTED IN THE U.K. AND EUROPE
BY F&W MEDIA INTERNATIONAL, LTD
Brunel House, Forde Close, Newton Abbot, TQ12 4PU, UK
Tel: (+44) 1626 323200, Fax: (+44) 1626 323319
Email: enquiries@fwmedia.com

DISTRIBUTED IN AUSTRALIA BY CAPRICORN LINK
P.O. Box 704, S. Windsor NSW, 2756 Australia
Tel: 02 4560 1600; Fax: 02 4577 5288
Email: books@capricornlink.com.au

Edited by Vanessa Wieland
Cover designed by Kelly O'Dell
Interior layout by Laura Spencer
Production coordinated by Mark Griffin

Metric Conversion Chart

To convert	to	Multiply by
Inches	Centimeters	2.54
Centimeters	Inches	0.4
Feet	Centimeters	30.5
Centimeters	Feet	0.03
Yards	Meters	0.9
Meters	Yards	1.1

Acknowledgments

To Vanessa Wieland, our editor at F+W Media, Inc., you are a star. Thank you for all that you did to make this another great *Absolute Beginner* book and thank you, especially, for bringing out the best in us.

A special thanks to all of the F+W Media, Inc. team who worked behind the scenes to make this another outstanding *Absolute Beginner* book, designers Laura Spencer and Kelly O'Dell and production coordinator Mark Griffin.

We want to thank our parents who instilled in us an appreciation of nature. Love and thanks to our mothers, Grace Patton and Clare Willenbrink. Loving memories of our fathers, Bud Patton and Roy Willenbrink, were sparked while we worked on this book.

Dedication

Laus Deo
Praise to God

We dedicate this book to our Lord, who is the Author of nature. We love experiencing His artwork.

This book is also dedicated to all who devote their time and energy to the care of our parks, natural spaces and wildlife. Your stewardship is greatly appreciated.

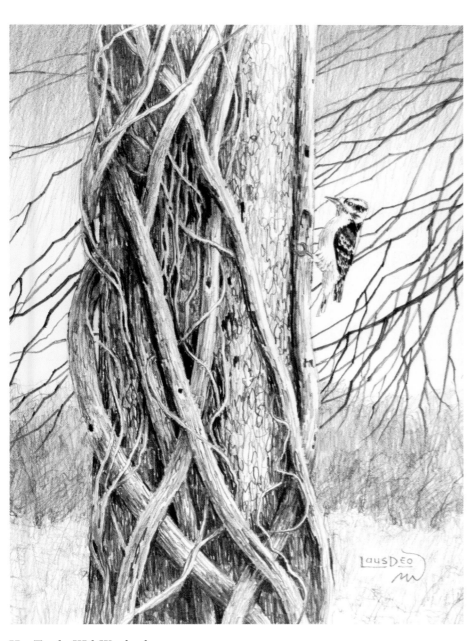

Vine Tangles With Woodpecker
Graphite pencil on drawing paper
13" × 10" (33cm × 25cm)